metal sculpture

metal

sculpture

NEW FORMS
NEW TECHNIQUES

JOHN LYNCH

THE VIKING PRESS
NEW YORK

By the Author

HOW TO MAKE MOBILES
MOBILE DESIGN
METAL SCULPTURE
HOW TO MAKE COLLAGES

Published by The Viking Press, Inc.
625 Madison Avenue, New York 22, N.Y.

Published in Canada by
The Macmillan Company of Canada Limited

Library of Congress catalog card number: 57-6177

Printed in the U.S.A. by The Murray Printing Company

CONTENTS

THERE ARE MANY EXCELLENT BOOKS ON METAL WORKING CURRENTLY available, but for the most part, they either limit the reader to the production of copper ash trays, wrought-iron end tables and the like or are simply manuals in shop practice. None of these books touch upon the popular new art form—*metal sculpture*.

It is the aim of the present volume, produced in response to many requests, to close the gap between technical proficiency and personal creativity by combining practical information on materials, tools and techniques with stimulating ideas drawn from the best contemporary work being done in metal sculpture.

Whether you wish to do wire sculpture—made easily by anyone with pliers and a wire coat hanger—or mobile making, or constructions of wire and metal (soft-soldered and silver-soldered) or monumental sculpture of welded steel, it is the basic premise of this book that the intangibles *inspiration* and *improvisation* are of primary importance. Techniques can be readily mastered by anyone who has the enthusiasm to learn them.

With this basic premise in view, the book stresses not only the work of acknowledged leaders in the field of metal sculpture, but also the painting and drawing of modern masters as well as the arts and crafts of ancient and primitive peoples. Each of these sources provides intriguing ideas for composition which the beginner should find easy to adapt. The artifacts of the past century and the model of a rocket ship of the future are equally productive sources of the all-important creative "idea."

Among the more mundane or practical reasons for the overnight growth of metal sculpture into a major art form are: our typically American delight in machinery and the casual ease with which we accept the industrial world and its products; the amazing amount

of information which the average man has about tools, materials and techniques of all kinds; our willingness to accept new things and our absolute relish for startling changes.

Another reason for the growing popularity of metal sculpture is the relatively low cost of producing a finished work. In general, the cost of materials and tools for contemporary metal sculptors averages about one-third to one-fourth the cost of work done in marble or cast bronze. Sculptors have traditionally been beset by great economic difficulties. Unless commissioned by a wealthy patron or civic group, a sculptor does not lightheartedly set about carving a costly block of marble. Or a sculptor might finish a model for casting, only to have the actual casting delayed for years because of the expense. Casting is so expensive in this country today that sculptors can save money, even with shipping costs included, by sending work to Italy to be cast.

Cost of materials, of course, has nothing to do with the aesthetic merit of the finished sculpture. Good, bad and indifferent work can be done in any medium. Metal sculptors, however, can afford the luxury of working out a good many of their ideas to their own satisfaction, and can economically produce works at a cost which the collector of modest means can afford. For example, you can make a piece of wire sculpture, a construction of soldered nails, a mobile or a sculpture of metal scrap (such as "Votive Object," figure 49) for only a few pennies. It is imagination, rather than any previous technical knowledge, that counts.

From tentative experimentation, using welding mostly as a means of creating sculpture that was not too radical a departure from other modern postwar sculpture, metal sculpture has attained a powerful form with its own constantly expanding frame of reference and its own imagery. An intimacy between materials, methods, techniques and ideas has been achieved, making possible the delineation of moods and feelings which could not be portrayed in traditional sculpture. As a modern art form, metal sculpture has tremendous potentialities. In this age of speed and change, the work of such men as Smith, Roszak, Lipton and Lassaw is already considered "classical" and occupies an important place in galleries, museums and private collections.

Contemporary taste in furnishing and decorating homes and offices has also contributed to the current demand for metal sculpture. A work such as de Rivera's "Sculpture Construction 2" (figure 113) is an absolute masterpiece of cool, gleaming, rhythmic construction, which could serve as a focal highlight in the most handsome of modern interiors. Sculpture such as Dorothy Robbins' "Family Cathedral" (figure 111), Lassaw's "Hathor" (figure 75), Lipton's "Sanctuary" (figure 110) and Andrews' "Stalks" (figure 106) have an interplay of space, light and material which is most welcome when actual living space is at a premium—as in an apart-

ment or small home, where calm, uncluttered rooms are a matter of necessity. Reverence for a marble staircase because it is marble, or for a bronze lighting fixture because it is bronze, is pretty much a thing of the past. Enjoyment of space and light and a greater sensitivity for the uses to which materials are put, rather than concern for their intrinsic value, are additional reasons for the wide acceptance of metal sculpture and the growing amateur interest in its techniques.

The "let's get to work" attitude of most Americans who delight in doing things for themselves finds a very satisfying outlet in the straightforward methods of the contemporary metal sculptor. No torturous processes, no complicated dealings with foundries, no utterly implacable materials interfere with the creation of the sculptured object, which remains in your hands from start to finish.

DEVELOPMENT OF CONTEMPORARY METAL SCULPTURE

METAL SCULPTURE, AS THE TERM IS USED IN THIS BOOK, means those forms of sculpture created through direct cutting and joining of metal shapes by bending or tying together, by soldering, or by welding, as opposed to the traditional methods of molding or casting. Generally speaking, the shapes themselves are abstract and usually continue to exist as independent units of the whole. In other words, they are not fused to form a continuous flowing surface as they would be in cast bronze (figure 1) which is a modeled, articulated envelope enclosing a spatial volume, as an empty bottle might be thought to enclose space in its own shape.

There is usually no attempt in metal sculpture to create an instantaneous illusion of reality; the sculpture either cleverly creates the illusion of reality or is frankly abstract. The contemporary metal sculptor presents us, so to speak, with the facts, and we reconstruct the idea, mood and observation which he intended to express. The impact is achieved through association of ideas—from broad intellectual "horseplay" to delicately suggested psychological and emotional concepts.

To anyone not too familiar with classical mythol-

ogy, the subject in figure 1 might require almost as much explanation as that of figure 2. Who is the god represented? What is he doing? Why are his hat and heels winged? What is he carrying in his left hand? What does the head (on whose bronze "breath" he is being supported) represent? All these questions, and more, might with justification be put to an art historian. Similarly, if we were to ask as many questions of a contemporary sculptor about Gonzalez' "Woman Combing Her Hair," which in an abstract way bears a rather startling resemblance in attitude to Giovanni Bologna's "Mercury," most of the seemingly complex difficulties of interpretation of the Cubist style would be readily clarified.

Three influences have contributed to the development of metal sculpture as it exists today: first, the Cubist analysis of form, which broke with the tradition of realism in painting and sculpture; second, the experiments of the extremist "Dadaist" group, whose artists used "found objects" to shock a conservative public; and third, the ever-increasing variety of tools, materials and techniques developed for industrial uses which sculptors have adapted in their continued search for new forms and new methods of expression.

Close correspondences of style and form have always existed between painting and sculpture. When Rubens' heavily dimpled ladies lounged about on two-dimensional cushions, hillocks, or clouds, bronze and marble maidens were similarly disporting themselves in three dimensions. The Cubist experiments of such painters as Léger, Gris, and Picasso influenced the work of their sculptor contemporaries—Laurens, Lipschitz, Archipenko, Duchamp-Villon and Gonzalez, among others. Shattering and reconstructing the elementary volumes of the human body as in Léger's "Le Grand Déjeuner" (1921), figure 3, and of objects such as a guitar or bottle, in an attempt to get at the abstract bases of all visual images, the Cubist painters and sculptors created a new vocabulary of depersonalized, completely unsentimental and nonliterary forms.

Gonzalez' "Woman Combing Her Hair" (1936), figure 2, is a characteristic example of the craftsmanship and unique, instantly recognizable Cubist style of this innovator and pioneer of welded-metal sculpture. Gonzalez had become familiar with oxyacetylene welding techniques while working for a time at the Renault automobile factories in France during World War I. Some of his best works, executed more than twenty years ago, continue to exert a strong influence on the present generation of metal sculptors in England and the United States.

The evolution of a new means of expression was of tremendous importance to the *avant-garde* painters and sculptors. They were destroying the accepted forms not merely out of boredom or hot-headed iconoclasm, but out of a need to express ideas and emotions which could no longer be expressed through the academic clichés of another age. In an effort to overthrow the tradition that

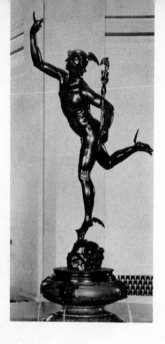

Left: Fig. 1. "Mercury." Bronze. Giovanni Bologna. (National Gallery of Art. Washington) Below: Fig. 2. "Woman Combing Her Hair." Wrought iron. Julio Gonzalez. (Museum of Modern Art)

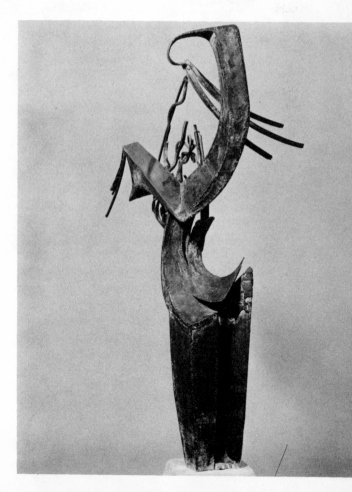

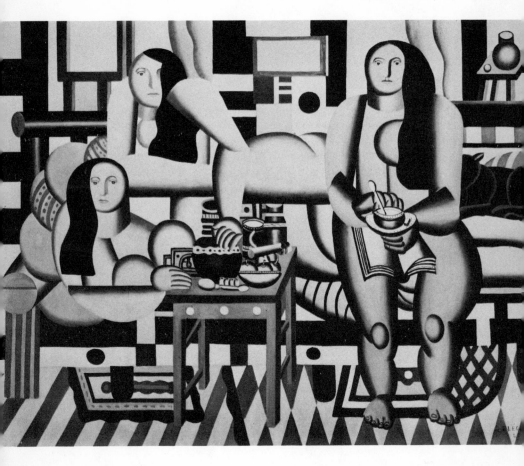

Fig. 3. "Three Women" ("Le Grand Déjeuner") (1921). Fernand Léger. (Museum of Modern Art)

bronze, marble and oil-on-canvas were the only proper media for "Art," some of the cubist painters began to incorporate into their paintings, such mundane material as scraps of newspaper, wallpaper, cloth package labels and string, as a further means of "affronting" the conservative public of their day. These experiments were eagerly seized upon and carried to extremes by a group of painters and sculptors who founded the "Dada" movement in Zurich in 1916.

The Dadaists' use of "found objects" was one of the principal tools of ridicule. Two elements were usually commingled in their work—anger and bufoonery. A whole new language of symbols, references and puns was invented to express the artist's attitude towards society. Since these ideas were largely negative, the range of institutions attacked was very broad. The "degraded" taste of the masses, supposedly the result of industrialization, as well as the inflated academic criteria for "Art," were equally targets for the Dada attack. "Nothing Sacred" was the most positive and consistent point of view. Max Ernst, Marcel Duchamp, Jean Arp, Picabia and Man Ray were among the most inventive and resourceful practitioners of this intellectual cult.

A classic example of the Dada attitudes and modes of expression is provided by Picabia's "Portrait of a Young American Girl in a State of Nudity (1915), figure 4. The "portrait" was manufactured from a catalogue drawing of a spark-plug, upon which the artist lettered the words FOR-EVER. It is rather a witty and at the same time bitter commentary upon the machine age in America—which, as the most highly industrialized nation in the world, was and still is an irresistible target for this brand of European tongue-in-cheek criticism. "The Bride" (1955), figure 5, by Richard Stankiewicz, is still within the tradition, forty years later, of Picabia's sly tour de force.

Fifty years ago many people would have considered the Gottlieb painting, "Voyager's Return" (1946), figure 6, which is now in the collection of the Museum of Modern Art, as "art"; and fewer would have accepted as "Sculpture" Harry Stinson's excellent work, "Signs of Spring," (figure 7) which he did in 1954. The hieroglyphic style common to both these examples has always been employed in one form or another in painting, sculpture and the decorative arts. But while sculpture rather similar to "Signs of Spring" could have been created six or seven thousand years ago, the intellectualization and consequent dematerialization of the idea of Spring is typically mid-twentieth century.

There is a startling similarity in Gottlieb's and Stinson's use of

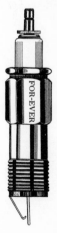

Fig. 4. "Portrait of a Young American Girl in a State of Nudity." Picabia.

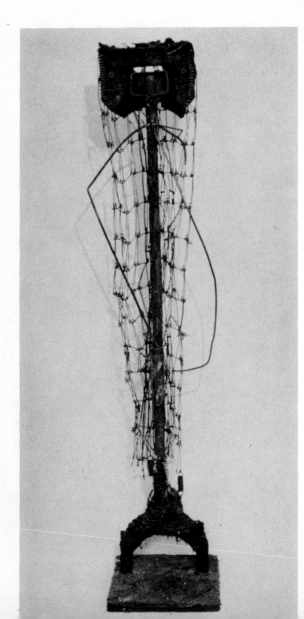

Fig. 5. "The Bride." Steel and fabric. Richard Stankiewicz. (Hansa Gallery)

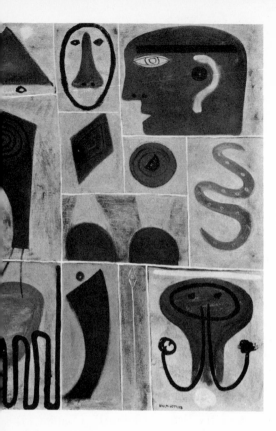

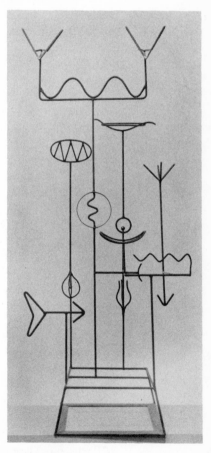

Above: Fig. 6. "Voyager's Return." Adolph
Gottlieb. (Museum of Modern Art) *Right:* Fig.
7. "Signs of Spring." Steel. Harry Stinson.
(Sculpture Center)

universal abstract symbols to express entirely different ideas, which presupposes a reliance upon the sophisticated interpretative ability of the reviewer. Oliver Andrews' "Spring Song" (figure 8) is another expression, in a sort of wiry shorthand, of an aspect of Spring. Traditionally, "Spring Song" might have been represented as an adolescent male or female nude, with arms outstretched, or in a dancing posture or playing a flute; or more sentimentally, as a little bronze girl, strewing bronze rose petals from a bronze basket. Without any literary allusions, however, Andrews' sculpture suggests a coltish adolescent, arms upraised, singing a very giddy song in a reedy voice, shouting and sprouting in complete response to the charms of Spring.

It is the business of the artist constantly to reinterpret the world for his fellow men, so that the ordinary stuff of life re-emerges fresh and exciting from the welter of utilitarian, sordid or dull uses to which it has been put. For our time, metal sculptors have assumed this wizard role, and we have come a long way since the early beginnings. Most of us can no longer fully accept the heroics of the generals, statesmen, poets and inventors who populate our public parks. Contemporary sculptors have recourse to a sign language that reworks these familiar bronze and marble formulas into a compressed symbology which the average man of the twentieth century interested in art can interpret to his own greater satisfaction. This reworking can be achieved through the simplest means, as in Toni Hughes' "Children on the Beach" (figure 15, Chapter 2), or through Stankiewicz' technically more difficult and certainly more blasé "Secretary" (figure 108, Chapter 6), or de Rivera's "Sculpture Construction 2" (figure 113, Chapter 6), which as a "cool" jazz afficionado might say, is "really far out."

In spite of the fact that they span a period of twenty-five years, the Cubist stylistic affinities of Picasso's "Seated Woman" (1926), figure 9, David Smith's "Head" (1938), figure 10, and Martin Craig's "Barbarian Queen" (1951), figure 11, are very close. Smith's "Head" was made before he began to work with the oxyacetylene welding torch. It is cast in iron and steel, but it could have been made from separately welded parts. The base, the throat and the crescent-shaped head outline certainly indicate the latter technique. The geometric feature forms provide a beautifully balanced counterpoint to the two-dimensional shapes. They too, could have been welded together from found parts arranged as in Craig's "Barbarian Queen," or formed by cutting and filing. David Smith's "Head" is interesting for its exploitation of drastically simplified masses, which reduce the human head to a geometric proposition intelligible to all. Eschewing exaggeration and arbitrary stylistic devices, this piece of sculpture expresses the fundamental, characteristic relationships of which all human heads are but variations.

"Barbarian Queen" is a synthesis of Cubist and Dada manner-

Fig. 8. "Spring Song." Galvanized wire.
Oliver Andrews. (Alan Gallery)

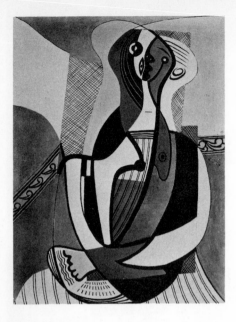

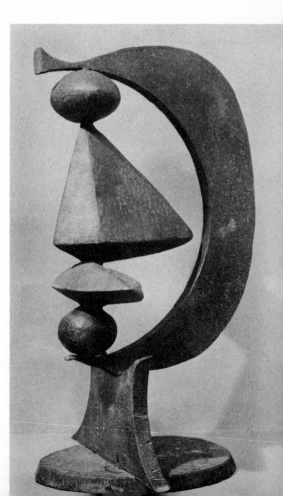

Opposite page, top: Fig. 9. "Seated Woman" (1926-27). Pablo Picasso. (Museum of Modern Art) *Opposite page, bottom:* Fig. 10. "Head." Cast iron and steel. David Smith. (Museum of Modern Art) *Right:* Fig. 11. "Barbarian Queen." Polychrome welded steel. Martin Craig.

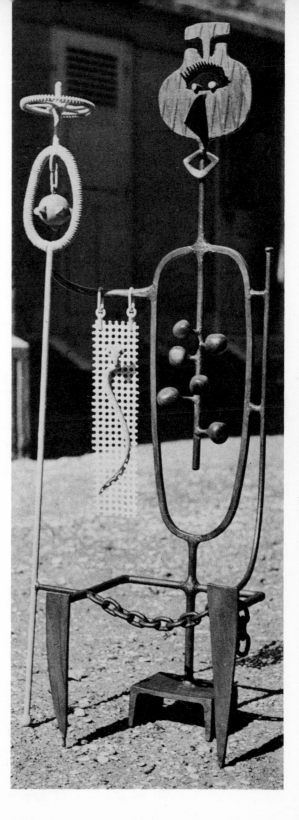

isms. It is made from a combination of scrap metals cut to shape and found parts such as the gear-toothed wheel atop the scepter form. The shield or garment sleeve suspended from the outstretched arm has been cut from a piece of perforated metal. A section of chain is looped across the legs, suggesting both a lap and very insubstantial royal robes. The six lopsided steel balls constructed within the body cavity are suggestive of some incredibly primitive visceral organization. (Craig explained that these were found in a junk yard and had been used in some sort of crushing machine.) The head, cut from a piece of steel having a raised pattern, successfully hints at the rather horrendous tattooing customs of some tribes. The tiny stool should also be familiar to anyone who has seen the innumerable *Life* photo interviews with tribal heads of darkest Africa; gorgeous raiment and inadequate thrones seem to be the rule. The sculpture, quite appropriately, has been painted black, white, red and yellow ochre.

Another ingenious method of using "found objects" in a more abstract manner is illustrated by Stankiewicz' "Mythological Story" (1954) figure 12. This might well be called a "junkscape" (a term I imagine he would approve). A picture in a frame, it tells a story of a battle uncannily well. It is something of a rather pat archeological "find." Its evocative power is due not only to the obvious pictorial arrangement of the rusted and battered artifacts but to the fact that in this era of push-button living there is a certain homely warmth connected with anything so simple as nuts, bolts and rusted wrenches, whose very familiarity is an aid to the evocative power of their new-found literary context.

In most of our big cities during the past ten years, architectural construction at every stage of completion has been a daily sight. Seen from different angles at all times of day or night, in every kind of light and weather, these skeletal buildings have a curious beauty and impose their steely, rigid patterns very strongly upon our subconscious. Yet a cast bronze replica of one of these half-finished skyscrapers would be uninteresting; it is only when they are at their most abstract that they can excite the imagination and stimulate creative variations.

The installation photograph, figure 13, of Sidney Gordin's sculpture at the Borgenicht Gallery immediately brings modern architecture to mind. Of course Gordin's sculpture is not merely an approximation of a skyscraper's framework; it is a beautifully worked out group of completely abstract spatial relationships which have the elegance and dignity of complicated geometric propositions. Trying to pin down influences too definitely can be futile. Whether or not Gordin was influenced by the abstract qualities of a building under construction, is not important. The forms are analagous and should encourage the reader to make similar comparisons as a source of inspiration for his own work in metal sculpture.

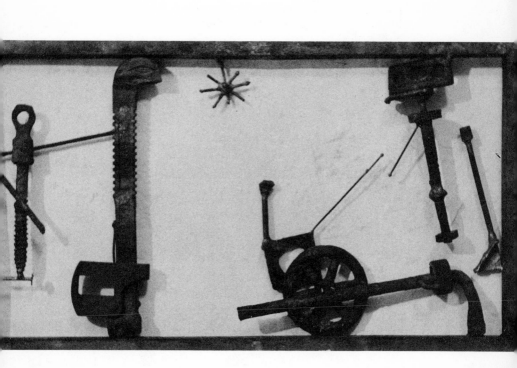

Fig. 12. "Mythological Story." Steel.
Richard Stankiewicz. (Hansa Gallery)

These analyses of form and an unprejudiced modern attitude towards everyday things are part of the Cubist-Dada inheritance of such contemporary sculptors as Smith, Craig, Stankiewicz and Gordin, whose work so perfectly illustrates the basic aims and concepts of contemporary metal sculpture.

Fig. 13. Abstractions. Sidney Gordin. Installation photograph. (Grace Borgenicht Gallery)

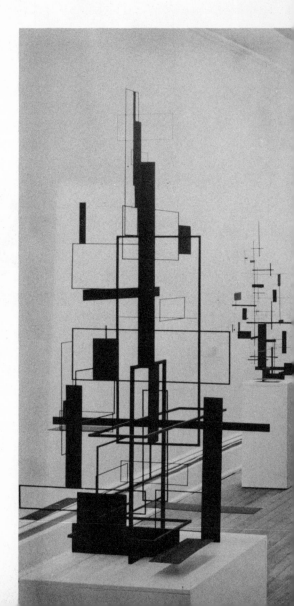

2

SCULPTURE WITH SHEARS AND PLIERS

(Wire and Light Metals)

THE WIRE AND METAL SCULPTURE ILLUSTRATED IN THIS chapter was purposely chosen from widely ·varied sources and periods. For instance, Calder's amusing wire figures in figures 18, 19, and 20 were made in 1928, the Inca diadem in figure 28 was cut out of sheet gold thousands of years ago, and the bird cage in figure 22—a useful and decorative construction— was made in France in the early eighteenth century. All these pieces were made with the skillful use of pliers and shears. They show the different sort of things that have been and still can be done with the simplest tools and techniques.

In this age of mass production and "disposables," it seems not only dull but anachronistic to emphasize technique to the exclusion of the sort of happy inspiration and improvisation that characterizes the works just mentioned. The danger of spending too much time carefully finishing details on small, utilitarian or decorative objects is that the amateur might, on his very first project, bog down, lose interest and give up. Another disadvantage is that a home workshop can grow to the proportions of a small factory in the process of acquiring tools, machines and gadgets, thus making a chore of what is supposed to be a pleasant, relaxing hobby.

My advice is to get started on some technically simple but well-designed project which requires no equipment beyond ordinary household tools, and to invest in additional tools only as your growing skill and interest in wire and metal sculpture requires.

Try fashioning a piece of wire into the outline of some familiar object—an animal, a streamlined boat or automobile, a man running —or make a face like the "Worried Man" in figure 21. Or take a discarded beer can and think of the various things you could make out of it by punching or cutting it into shapes. As a first project, you might make a face out of it, as you would with a pumpkin, or you might make a lamp base or plant holder, or a lantern like the one in figure 51. Elaborate equipment is certainly indispensable to professional metal sculptors of the stature of the men whose work is illustrated in Chapter 6, but for an enjoyable amateur project it is absolutely unnecessary.

From Calder's intriguing wire (figures 18, 19 and 20) to Bertoia's gigantic metal screen (figure 123, Chapter 6) is a long step in technique. But Calder's use of a piece of wire is as imaginative as Bertoia's use of steel and welding equipment. The conception, point of view, inspiration, and unique idea are of primary importance.

No more than average mechanical skill was needed to produce the useful objects such as the lamp (figure 57), the decanter (figure 23), and the candelabra (figure 58). The designs are the result of an acquaintance with antiques, some knowledge of art history and an enthusiasm for modern art. These influences are, of course, very indirect, but their cumulative effect is strong enough to sharpen a sense of abstract form and break down prejudices in modern or traditional sculpture, painting and decorative arts.

In New York City, for example, both the Museum of Modern Art and the Metropolitan Museum of Art are stimulating as sources of design. Indeed, one makes the other more exciting. Studying a Chinese bronze utensil of the seventh century B.C. or the latest utensils of the twentieth century at a Good Design show is equally rewarding. But whatever you do, choose simple designs for your first projects, and keep them small in scale.

TOOLS

Of the tools shown in figure 14, one pair of pliers and a metal shears are absolutely indispensable for simple metal sculpture. Shears with straight cutting edges, known as tinsmith's shears, may be bought for very little at hardware stores or the five-and-ten. They could be substituted for the curved-nose shown, which are designed for cutting complicated curves and circles and are more expensive. The pliers to the left of the vise I bought more than three years ago for 39 cents and they are still my favorite for gen-

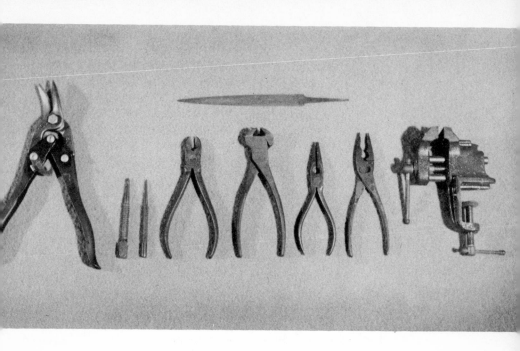

Fig. 14. Beginner's metalworking tools. *Left to right:*
Shears, two center punches, two wire clippers, two
pliers with cutters at side, vise, and *(top)* fine flat file.
(Photo: Herbert Skoble)

eral use. The long-nosed pliers are more useful for working with
fine wire and getting into tight places; also, since they broaden to-
wards the base, they help maintain a tight grip on a wobbly piece
of work.

Actually a separate wire cutter is often handier—it cuts more
easily because of the greater leverage and stays sharp longer. Wire
cutters are made in many shapes and sizes for different cutting op-
erations. Those in figure 14 with cutters at the top are useful for
nipping off excess wire in places where those with cutters at the
side might prove awkward. These and other refinements are more
important to anyone working with metal over a long period of
time. They are not necessary for the beginner or "Sunday metal
sculptor."

Almost any hardware store carries a great variety of these basic
tools. Some are very specialized, but again I stress the advisability
of choosing simple, substantially made tools at first. And in this
connection I might point out that, contrary to what a great many
people think, cheap tools are not necessarily the best for light
work. Nothing is more frustrating (and dangerous) than a flimsy

piece of equipment. It is much harder to drive even a small nail with a cheap spindly hammer than with a good solid one. With tools that are too small and poorly made, you are much more likely to make slips at the expense of your fingers. Delicate, specialized tools are best used in conjunction with solid workmanlike tools. For very little more you can buy a precisely machined tool which will do a much better job for a longer time. And since most of the tools illustrated in figure 14 can be used for a thousand and one household chores, they are certainly worth the little extra investment.

METALS

Except for very special alloys, metal sculptors use most of the various forms in which metal is manufactured for industrial use. Sheet, strips, circles, rod and wire are produced in dozens of gages, lengths, widths, thicknesses and other dimensions which are standard and which apply to all metals. Sixteen-gage copper wire, for instance, is as thick at its diameter as 16-gage copper sheet. The same is true of all other metals in all gages. You should have no trouble finding galvanized iron wire in gages from 10 to 18, or tinned sheet metal in easily workable gages, at a hardware store or tinsmiths.

Copper and brass sheet and wire should also be readily available. If your local hardware store doesn't stock it, the proprietor should be able to tell you where to get it, or order it for you. Steel in one form or another might be more difficult to obtain, but might be obtained as scrap (along with aluminum and any other metal) from a nearby small factory, scrap metal dealer, junkyard or second-hand auto parts dealer. If metals are scarce in your particular neighborhood, you might make a practice of collecting such stray pieces as you come across from time to time. Country auctions yield an amazing amount of metal objects that are often sold at "junk" prices. Old metal can be polished up with steel wool or painted. Cans from the kitchen or gallon cans that have served their purpose as containers for gasoline or other liquids are useful for many projects.

IDEAS

Simplicity of ideas and materials does not in any way imply dullness. Fortunately for the beginner the basic approach of the contemporary metal sculptor is direct. He picks up a piece of metal and starts to work with it. It is from this *handling* of the material, in the most literal sense of the word, that the sculpture begins to grow and take shape from the metal itself, so that the simplest piece of metal offers a great many creative opportunities. It can be cut, bent, twisted or folded to make the begininng of an evocative, wholly successful collaboration between material and idea.

Toni Hughes' "Children on the Beach" (figure 15) is a charmingly apt illustration of this point. Made of screening, plumber's tape, strips cut from sheets of perforated metal of various patterns, and even a few lengths of would-be girder from an Erector set, this composition winsomely recreates the gaiety of children frolicking on the beach. The screening and tape components of the figures are joined with small nuts, bolts and washers. Only the oldest and most dignified child has two feet on the ground, held there firmly by small wood screws, as are the more playfully "shared" feet of the younger children. This is one of the many ways of making

Fig. 15. "Children on the Beach." Plumber's hanger iron, galvanized wire cloth, screening with various ornaments. Toni Hughes. (Museum of Modern Art)

metal sculpture with pliers, shears and—in this instance—a screw driver. The driftwood plank has been cut even at both ends, but this is entirely a matter of taste. We have all seen rough, weird pieces of driftwood used both as sculpture in themselves and as bases for amusing wire sculpture in the form of birds and animals.

One particularly pleasing piece of wire sculpture I remember was made from wire coat hangers, bent to form a fish. The scales were made from small clam shells (holes courtesy of some unseen marine borer) held in place with finer wire that had been salvaged from the beach as well. There is something about a beach littered with shells, driftwood, odd fragments of glass, beautiful pebbles, dried kelp and seaweed, rusted nails, pieces of wire and all sorts of junk—transformed and somehow made terribly antiseptic and impersonal by the sun and waves—that brings out the scavenger in most artists. I have never spent a summer at the beach without making a half dozen constructions, sculptures or mobiles out of these ghostly, derelict finds, or seeing similar bits of phantasmagoria at friends' cottages.

Without a constant awareness of the layers of meaning and power of suggestion which the most common objects possess—as in the Steinberg drawing (figure 16) where through very persuasive sleight of hand a scissors and penknife convince us that they are a pair of spectacles, a long sharp nose, and an angry looking bird—we are sadly limited to the stereotyped literal interpretation of forms, of which we soon grow weary. Oliver Andrew's "Spring Song" (figure 8, Chapter 1) is another fine illustration of the suitability of the simplest materials and techniques to a theme. It is made of galvanized iron wire wrapped around a rigid framework of heavier rods. It is fresh and spontaneous and makes its point with the utmost economy of means.

Paul Klee's "The Mocker Mocked" (figure 17) may give an idea for a head to be worked out in wire, like Calder's doodles, which are just the sort of thing that can be done on spur of the moment with pliers and a few of those surplus and ubiquitous wire coat hangers. They are humorous, freehand sketches with which we could happily occupy an hour or more. I'm sure we've all come home from a party with the memory of someone who looked, or tried to look, like the Grande Dame in Calder's wire construction (figure 18), fluttering about in our minds eye and rankling a bit. Calder did something about it, displaying wit and skill in his simple caricature.

There are endless possibilities in wire sculpture. The pastoral scene also provided Calder with material for the same good-natured satire in wire. The "Sow" (figure 19) and the "Cow" (figure 20) capture the comic aspect of farmyard animals while showing a very keen eye for their absolutely characteristic forms.

The wire portrait bust "Worried Man" (figure 21) is a close-up

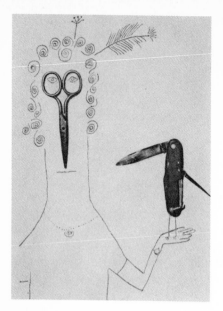

Left: Fig. 16. Collage. Saul
Steinberg. (*Flair* Magazine)
Below: Fig. 17. "The Mocker
Mocked" (1930). Paul Klee.
(Museum of Modern Art)

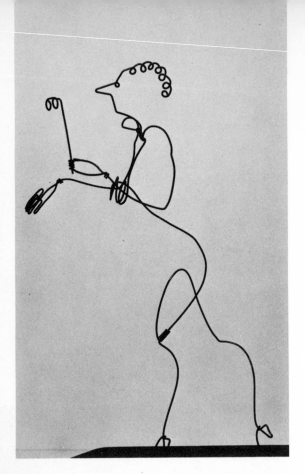

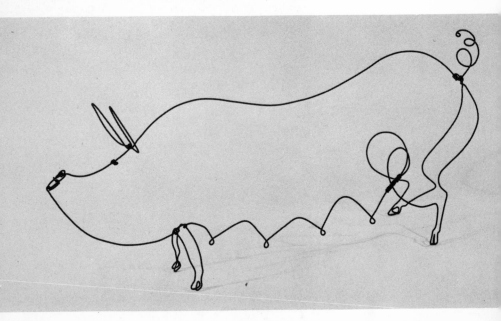

Left: Fig. 18. "The Hostess." Wire. Alexander Calder. (Museum of Modern Art) *Below:* Fig. 19. "Sow." Wire. Alexander Calder. (Museum of Modern Art)

Above: Fig. 20. "Cow." Wire. Alexander
Calder. (Museum of Modern Art) *Below:* Fig.
21. "Worried Man." Wire. John Lynch.
(Photo: Herbert Skoble)

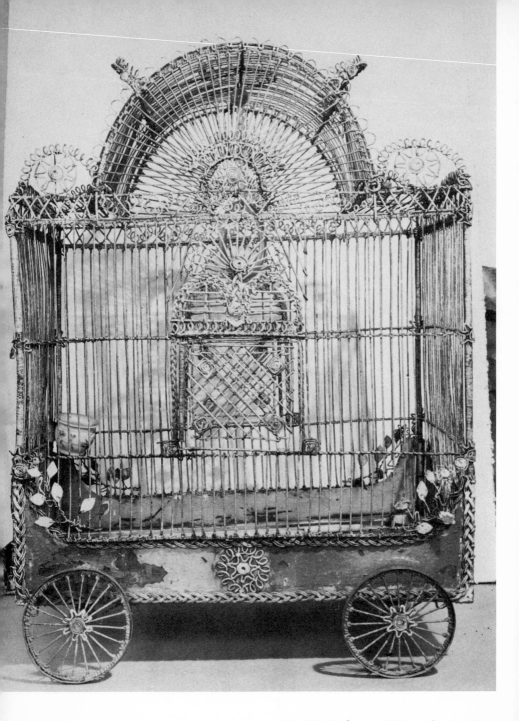

Fig. 22. Bird cage. Wire and painted tin. French; 18th century. (Cooper Union Museum)

in contrast to Calder's full-length portrayals. It is a composite portrait inspired by the faces one so often sees across the aisle of a city bus. The technique is also suitable to serious portrait efforts as well as caricature. The features are made with 26-gage wire, the frame of 9-gage aluminum wire (sold in the form of wire clothes line at many hardware stores). Aluminum is a very pleasant material to work with—clean, flexible, bright, rustproof and inexpensive. The carefully slicked-down hair is a length of 18-gage galvanized iron wire, looped back and forth and crimped to suggest a part. Various gages are useful for suggesting texture, weight and intensity of line, such as one obtains with hard and soft pencils when drawing. The pupils at the center of the wire iris are made of chips of pink glass, which accentuate the weary quality of the eyes. A very amusing face could be made from wire and found objects of all kinds. For example, an interesting and amusing effect could be obtained with beads, buttons, washers or bottle caps for eyes, large safety pins for ears, a piece of broken comb for a mustache and almost anything round, square, or oval for a mouth.

The bird cage in figure 22 is a very busy confection which shows that there's nothing particularly new about the idea of constructions made entirely of wire. Its anonymous maker lavished much imagination and considerable patience on its creation. The fact that it is still with us more than two hundred years later proves that many people have enjoyed and chershed this bit of whimsy. Its wedding-cake quality might make it a bit too rich for modern tastes, but as a source of inspiration for anyone interested in making a more charming home for his favorite bird it is practically inexhaustible. One wouldn't expect bird cages to be serious works of art, but the usual "store-boughten" ones certainly lack any element of fantasy or decorativenesss. This uninhibited approach should, at least, prompt you to add a few flourishes to a bird cage you might already own, if you don't feel that you must start from scratch. If you do, chicken wire would be a good material to start with, since it can be pushed, pulled and poked into any shape. It is also amenable to an unlimited variety of decorative treatments. For example, small objects can be hung or fastened in the spaces, or strips of metal can be braided or woven in and out in any manner you choose. A round or oblong cake pan for the bottom and a few rods or lengths of heavy wire for a framework will make a pleasant and permanent enough home for the average bird.

Another utilitarian object that can be made in a very short while using wire and a Chianti bottle, is the "Decanter" (figure 23). A length of aluminum wire (the same used for the outline of the head in figure 21) approximately 6 feet long, has been bent to form five legs. Fine, flexible wire (26-gage), which can be bought at radio and television supply stores, was doubled and woven to form the mesh which entirely covers the bottle and holds the legs in

Fig. 23. "Decanter." Chianti bottle, wire mesh on aluminum wire legs. John Lynch. (Photo: Herbert Skoble)

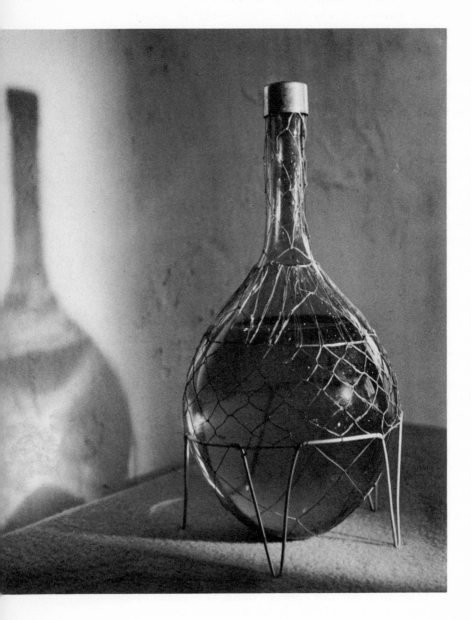

place. It is looped around the horizontal connections between the legs, made to conform to the shape of the bottle by a series of slight adjustments, and continued to the top of the bottle. Four rings of this fine wire encircle the bottle and are used as anchorage for the changes of pattern. There are four variations woven into the basic diamond-mesh pattern. The mesh above the legs is four times as small as that below. The third division was made by looping wire up and down, while the fourth is the original pattern. The cap is that of the canister made into a lamp in figure 57, which again just happened to fit. Used as a water carafe or decanter for summer drinks, it looks very much at home with garden furniture on a terrace or patio.

Completing a simple project like the decanter is a good way of getting the feel of working with wire and of achieving quick and useful results as a reward for your efforts. Looking through art books and magazines of all kinds is one of the most fruitful ways of getting ideas for things to make. For example, Erwin Christensen's book, *Primitive Art,* is filled with wonderful illustrations of sculptured figures, decorative and utilitarian objects made by primitive peoples all over the world that lend themselves well to adaptation for contemporary design.

One such illustration, the "Mica Ornament" (figure 25) in the shape of a hand, from the prehistoric Hopewell mound-building culture of the Ohio Valley, is a vivid realization of the abstract beauty and power of the human hand. This is a logical form to dignify as an ornament for a people whose necessities and cultural artifacts were entirely the work of their own hands. It is a first-rate illustration of how rich a source of design the handicrafts of a primitive people can be. As an ornament put to use, it would be very effective and decorative cut from sheet brass or copper, highly polished, and used as a door push-plate instead of the conventional rectangle of metal or plastic. It could also be supplied with a little leg at the end of each finger, and one at the base of the palm, and used as a kind of anthropomorphic trivet. This suggestion is not as far-fetched as it might sound—only recently in an antique shop I saw a small oval ceramic dish with a dainty hand growing out of its center, which turned out to be a Victorian ring holder. Its unknown designer amused himself and pleased a great many other people, much as Calder does constantly with such useful trifles as the Cubist spoon or the forks and strainer shown in figures 26 and 27.

The spoon in figure 26 is formed from a single strip of aluminum about 7 or 8 inches long and 2 or 3 inches wide. The bending and joining are as ingenious as that of the parlor-trick birds and animals of folded paper. It is a useful object made doubly enjoyable because of its obvious cleverness and good design. A careful study of the two views of the spoon will enable anyone to figure out how it

Above: Fig. 24. "The Duck." Copper and brass wire. Valerie Clarebout. *Below:* Fig. 25. Ornament in shape of human hand. Mica. Hopewell Culture, Ohio. (Chicago Natural History Museum)

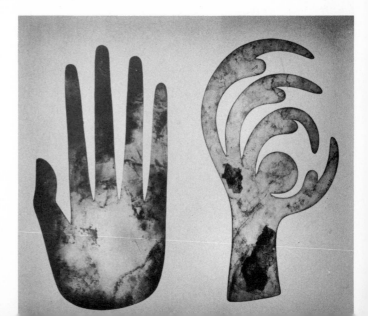

39 4111

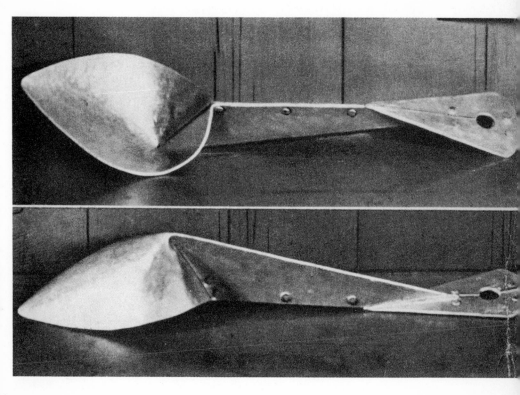

Fig. 26. Spoon. Aluminum. Alexander Calder.

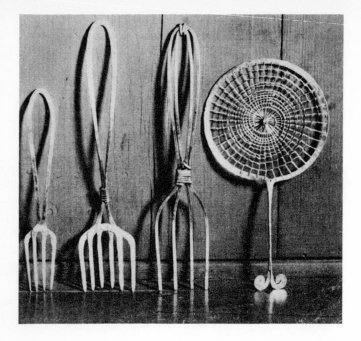

Fig. 27. Forks and strainer. Aluminum.
Alexander Calder.

has been done and will probably tempt the reader to make one
or some other utensil like it. Try folding a 6-inch × 2-inch strip of
heavy paper down the center lengthwise for about three quarters
of its length. The bowl of the spoon will be formed by the un-
folded portion at the end, and can then be trimmed to shape.
The handle is also cut to shape, folded, then trimmed again for
refinements. Experimentation with paper will allow you to work
out the details of construction before you cut into a sheet of alumi-
num. Home-made rivets could be made from a ¼-inch length of
9-gage aluminum wire, pounded with a hammer on an anvil or
other firm metallic base until a head is formed large enough to
hold the two pieces of metal tightly together.

The forks and strainer in figure 27 are also diverting examples
of household utensils, reminiscent of those used in seventeenth cen-
tury American homes. They are made of strips cut from sheet
aluminum, bent to shape. The handles and outermost prongs are
formed of one strip, the center prongs of a smaller strip bent and
riveted in place. The smallest fork in figure 27 has one such center
unit, the middle fork has two such units, making six prongs, and
the fork next the strainer consists of two similar units which form

a double handle and four prongs. Calder's improvisations have solved the mechanics of forkmaking very neatly and attractively.

Another good reason for making utensils, aside from the fun of it and the modest sense of achievement, is that such homemade articles can often answer special needs. There are many mass-produced utensils that are exasperatingly inadequate for one or another special little task. A toasting fork that would be more comfortable if it were a few inches longer or shorter, or a strainer (such as the one in figure 27) which, aside from its uniqueness and decorative value, might solve some culinary problem, could be fashioned by the amateur handyman at next to no expense in the basement workshop.

Using no more than shears and a few simple dies for stamping designs in the metal, the Incas thousands of years ago made fabulous gold ornaments, like the Colombian diadem in figure 28, with a freedom and casualness that is breathtaking if one stops to consider that these ornaments are made of almost pure gold. To snip a piece from a thin sheet of hammered gold as if it were paper, punch designs and holes in it and attach it to a similar piece with a ring formed of gold wire requires a high degree of self-assurance. This sort of frontal assault is one this age of mechanical gadgetry might find refreshing as a method of working.

The Mexican ornament in figure 29 is about a thousand years old, yet it has a vitality that immediately recommends it to the modern eye. A copy or adaptation of this ornament, made in copper, brass or silver, for use as a belt buckle, clasp for a leather purse or worn as a brooch, would be interesting and in good contemporary taste.

The fish has been the subject for hundreds of design variations on its already quite abstract form, which are universally recognizable and perenially popular with painters, mobile makers and metal sculptors. Their streamlined simplicity permits the greatest freedom of interpretation, as evidenced by no less than six illustrations (figures 30, 31, 45, 64, 83 and 86).

As an initial project, the fish form is a very satisfactory one for the beginner to experiment with. The design in figure 30 is made from a piece of .012-gage tinned sheet metal, punctured alternately on both sides with an ordinary beer-can opener. These rows of raised triangular shapes approximate scales uncannily well. Puncturing a piece of sheet metal with a variety of sharp instruments is one of the simplest and most direct methods of creating a textured surface. In order to do this without bending the metal, the punctures should be made by placing the metal over a cylinder of metal or wood (a small tin can or wooden spool) with an opening approximately one inch in diameter. The tail of the fish in figure 30 is cut with metal shears and the head patterned with dots by tapping lightly with the point of the opener.

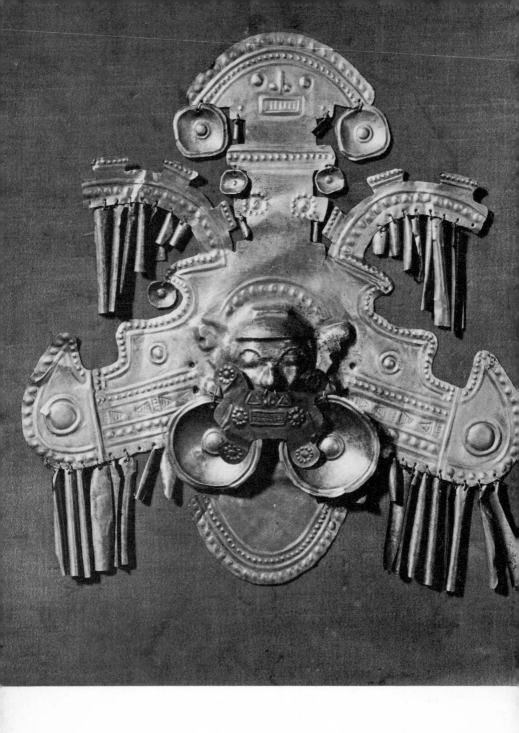

Opposite page: Fig. 28. Diadem. Gold. Calima style. (National Gallery of Art, Washington) *Below:* Fig. 29. Nose ornament. Gold. Mexican (Mixtec-Zapotec). (Rhode Island School of Design)

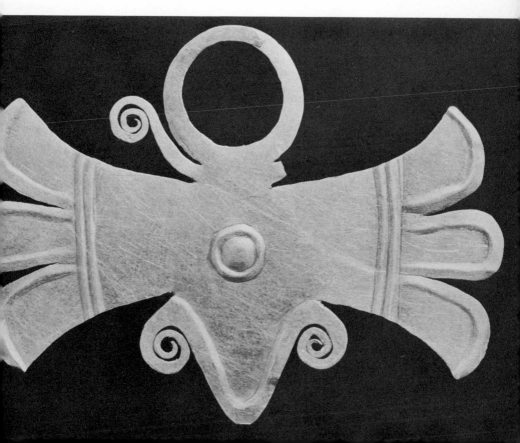

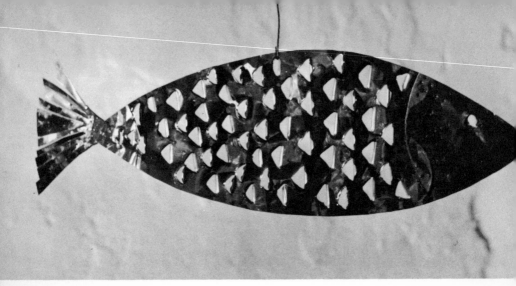

Above: Fig. 30. "Fish." Tinned metal, punched.
John Lynch. *Opposite page:* Fig. 31. "Sunfish."
Aluminum wire, tinned metal strips. John
Lynch. (Photos: Herbert Skoble)

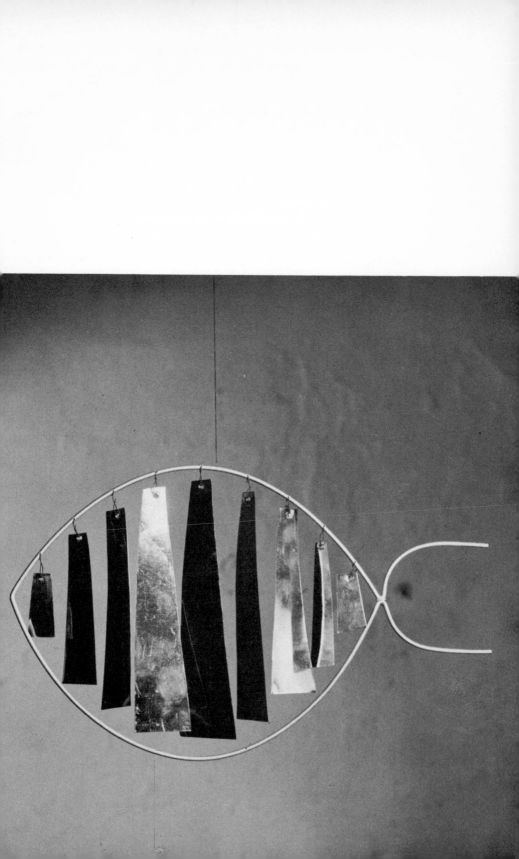

The "Sunfish" (figure 31), made of the same tinned metal cut into strips, is extremely effective because the silvery pendants recreate the gliding, twinkling motion of a swimming fish. They also suggest water because they reflect light. You might make this fish of strips of stained glass, windowpane glass, copper, brass, or silvered cardboard. The frame for this design (made of 9-gage aluminum wire) was drilled with a very fine, No. 58 high-speed metal drill at even intervals, making holes to hold the wire hooks. The hooks, made of 40-gage spring steel wire, are the connecting links between frame and pendants. Actually, any fine flexible wire could be bent to form hooks and wrapped around the frame, obviating drilling. Hung on a nylon thread at the balance point, the fish constantly revolves in response to every current of air. If metal or glass is used, a slightly musical sound is produced whenever the pendants touch. The silvery tinkling, the silvery reflections, silvery finny movements, are a cinematic representation of the slithery, twinkling passage of a fish through water. The metal pendants could also be painted or sprayed with transparent lacquers if color is desired.

Fred Farr has used a skeletal fish as a silver ornament (figure 64, Chapter 4). The fish by the author (figure 83, Chapter 5) is made of soft aluminum wire woven back and forth and knotted at the intersections to form a large, rotund fish weighing no more than a few ounces. It could be hung outdoors over a garden pool, since the wire is rustproof. And the fish in "Around the Fish," by Paul Klee (1926), figure 45, Chapter 3, would be an exotic model for a more complex wire construction.

These constructions, wire and metal sculpture and jewelry are all based upon elementary forms. Many of the projects in this chapter are so simple that a child could work them out at home or in the art class of an elementary school.

Another fascinating and popular metal working project for a beginner is provided by *mobiles*, a form of metal sculpture to which the refreshing qualities of effortless movement have been added. Devised by Alexander Calder in the early 1930s, mobiles combine some of the Cubist analyses of form with some of the Dada levity to produce constructions of an engaging and graceful sort of restlessness. The broad general characteristic movement of each mobile can be planned ahead, and quite subtle varieties of movement can be incorporated.

The methods used to cut and join the components of a mobile are very simple. Metal shears and pliers are the only tools needed to make a mobile similar to that in figure 32, which the author built up of nine discs of thin, .012-gage metal cut with shears and joined to eight arms of 16-gage galvanized iron wire. Beginning at the bottom, each piece was joined to a wire arm; the balance point of each arm was then decided and each arm joined to the next. The

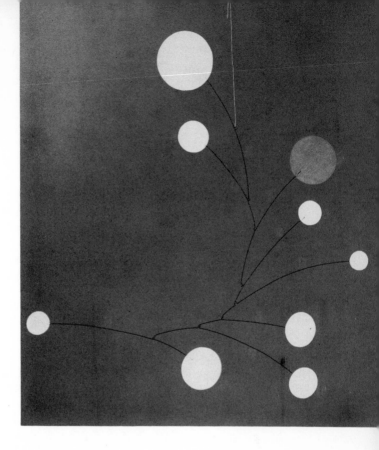

Fig. 32.
"Nine Circles."
Metal mobile.
John Lynch.
(Photo: Adolph Studly)

length of each arm and the size of the circle was decided before
balancing. Since by one means or another any shape can be bal-
anced at any angle, the general outline of the mobile's composition
can be planned in advance, and the balance points placed so as to
preserve these relationships. The method of joining pieces to arms,
finding the balance point at which the balance loop is to be made,
and joining one arm to the next is illustrated in figures 33, 34 and
35. After construction, the mobile was painted—the wire arms
black, the light discs white, and the single, darker disc (number 7)
red.

You might try making a mobile by first using cardboard pieces
attached to wire arms fashioned from coat hangers, then repeat it
with elaborations and variations in metal. The two small table
mobiles by Calder, (figure 36) and the "Rat" (figure 89), were con-
structed mainly with this technique. The mobile units are balanced
atop the tripod bases by an ingenious method. A shallow depres-
sion is pounded into the horizontal plate to which the mobile units
are attached. The plate rests on the pointed apex of the tripod and
the unit is free to make a complete revolution about the base.

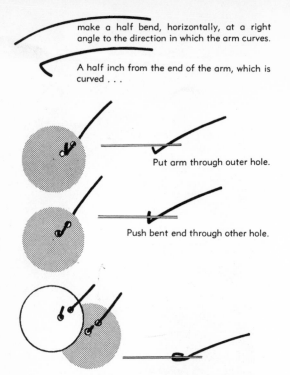

make a half bend, horizontally, at a right angle to the direction in which the arm curves.

A half inch from the end of the arm, which is curved . . .

Put arm through outer hole.

Push bent end through other hole.

Now push bent end flat against piece.

Above: Fig. 33. Steps showing how to attach a shape directly to the end of an arm. *Below:* Fig. 34. Finding the balance point of a mobile arm. (Photo: Adolph Studly)

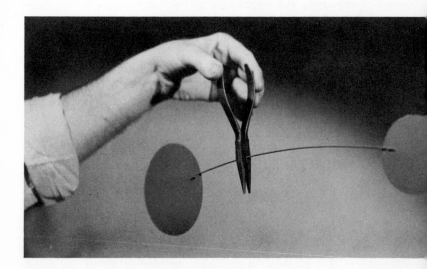

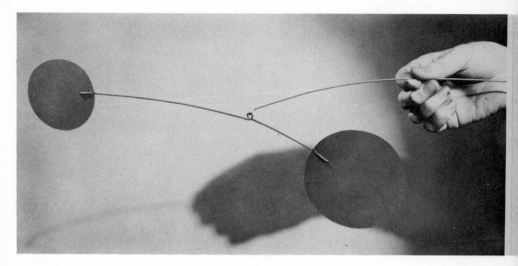

Above: Fig. 35. Method of joining one mobile arm to another. *Below:* Fig. 36. Table mobile with stabile base. Painted metal. Alexander Calder. (Photos: Adolph Studly)

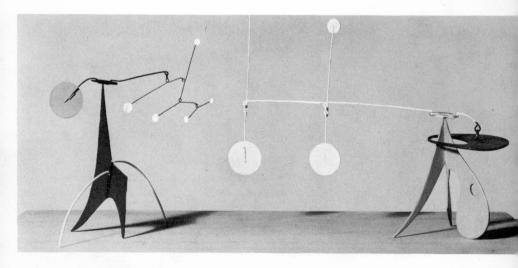

Fig. 37. Directions for making a flexible coiled wire bracelet (Courtesy Handy & Harman). You will need 12 to 15 feet round wire (18 or 16 gage), flat-nosed pliers, old scissors or metal snips. Cut the wire into 6-inch lengths with one unit of 7 inches for the clasp.

1. Grasp the end of the wire with the pliers and make a sharp right-angle bend. The ⅛-inch end by which the wire is held will be cut off when coiling is complete, leaving the wire unmarred by the pliers. A sharp bend is a necessary beginning for flat, even coils.

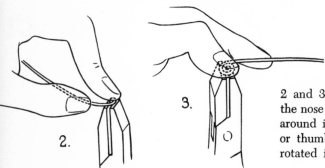

2 and 3. Hold the wire firmly against the nose of the pliers as you coil the wire around itself by pushing it with fingers or thumb of one hand while pliers are rotated in opposite direction.

4. Coil all the 6-inch lengths of wire until they measure 1¾ inches. Coil the 7-inch length to measure 2¾ inches. Snip off ends held by pliers.

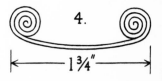

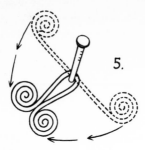

5.

5. Pull each unit around the nail.

6.

6. Bend first unit, keeping a full, round curve to give freedom of movement to the units.

7.

8.

7 and 8. Insert the second unit in the first and bend it as you did the first unit (sketch 6). Insert the third unit into the second and bend. Continue with the remaining units.

Should you be interested in developing your skill at this particular branch of metal sculpture, detailed methods of constructing mobiles are given in the author's previous books: *How to Make Mobiles* and *Mobile Design*. I consider Calder's work the definitive source of technique and design, and as such it should be studied in photographs and in museums or private exhibits whenever possible.

Making Jewelry without Soldering

Decorative jewelry can be made using only wire and pliers. The necklace shown in figure 38 is made of 16-gage sterling silver, but any other attractive 16- or 18-gage wire—copper, brass, aluminum, or stainless steel—may be used. Other types of jewelry, requiring silver soldering, are discussed in Chapter 4.

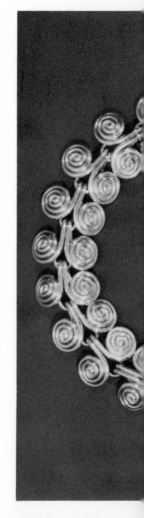

Fig. 38. Necklace made from twelve feet of sterling silver round wire, worked in the same way as the bracelet shown in figure 37. (Photo: Courtesy Handy & Harman)

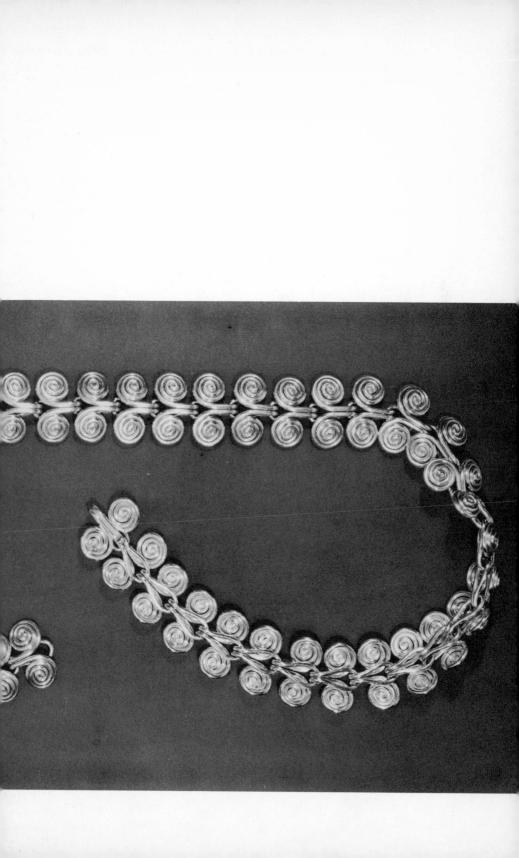

3 | INTRODUCTION TO SOFT-SOLDERING

ALTHOUGH WIRE SCULPTURE AND A GREAT DEAL OF other metal sculpture can be made simply by twisting wire with pliers or cutting a sheet of copper, brass or tin with shears and bending it, decorating it by scoring or stamping designs or cutting holes in it (as in the examples shown earlier in this book), soldering offers new possibilities as a method of working with metal. Let it be emphasized that no one need be scared off by the idea of soldering, for it is a very easy operation—just about anyone can do it. It is cheap, too. A good soldering iron for light work (as shown in figure 39) can be bought for less than a dollar.

Learning to solder is, for our purposes, more a method of achieving effects than a technique to be mastered for its own sake. Even the artists who used oxyacetylene welding to creat the metal sculpture illustrated in Chapter 6 were not concerned with the physical and chemical properties of metals but with their visual and expressive qualities. Soldering and welding are both means to an end—the creative expression of an idea in metal.

Soldering may become part of the composition as in "Clouds and Mountains" (figure 44), where it is important to the design so that the pieces barely

touch one another, and where splashed solder is used as rain-drops: or as in "Sun and Boat" (figure 48), in which rays made of nails and short lengths of wire are so unobtrusively attached to the circumference of the "sun" with almost invisible drops of solder that we are hardly conscious of how it was put together. Concealing or making a point of the technique used thus becomes a matter of choice for aesthetic rather than mechanical reasons. If desired, a soldered joint can be partially or totally camouflaged with paint.

As soon as you have acquired some facility in soldering, it would be a good idea to look through the rest of the book for ideas that can be adapted to the use of soft-soldering and lightweight wire and metals. Aside from its descriptions of specific projects, the reader should from the start regard the entire book as a reference work. He should not skip the section on welded sculpture as being perhaps too difficult. He may or may not decide to tackle welding, but he is urged to study *all* the illustrations as potential sources of inspiration for whatever type of wire or metal sculpture he decides he would enjoy doing most. The reader is not asked to plod dutifully step-by-step through the book, although it progresses in logical sequence from simple wire sculpture to more complex achievements in welded steel. He may begin at any point which seems to offer a chance to work in a vein which suits his abilities or strikes a responsive chord. There are no hard and fast rules to be observed. A different material or technique may be substituted for the one described in order to produce whatever results are aimed at, or to produce as good results as possible under limitations imposed by the materials and tools available.

Several illustrations of welded sculpture (figures 40, 41, 42, and 43) have purposely been introduced into the present chapter to acquaint the reader from the beginning with some of the various ways in which metal has been handled by professional sculptors who use welding as a technique. The inclusion of these examples will suggest many more enjoyable projects to a reader adventurous enough to adapt such designs in wire or lightweight metals which he can soft-solder. A study of the sophisticated concepts of some of our leading contemporary metal sculptors will usually suggest ideas similar in concept or mood. These ideas can be adapted to different materials and techniques.

"Ostrich" (figure 40), is a welded sculpture made of wire and small irregular pieces of metal. The wire serves both as an armature for the hollow body and as the legs of this prancing bird. The neck and head are formed of very small irregular pieces of metal welded over the wire to make a continuous, sculptured surface. The body is formed of larger irregular shapes joined with small blobs of bronze welding rod. The legs and feet are composed almost entirely of melted welding rod, built up and modeled over the wire armature. Soft or silver solder may be treated in the same

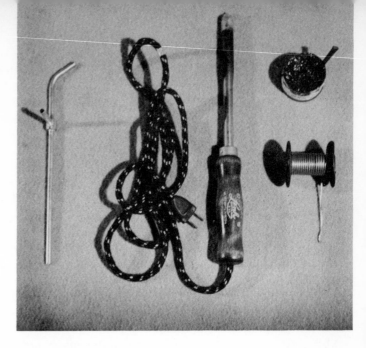

Fig. 39. Soldering iron for soft-solder,
flux *(top right)*, soft wire solder *(bottom
right)*, and blowpipe *(left)* for alternate
method of soft-soldering (see text).
(Photo: Herbert Skoble)

manner. In all cases the molten metal will build up in the same
way as drippings from a wax candle, and may be used as in this
sculpture or as in Lassaw's "Kwannon" (figure 109, Chapter 6), or
Lipton's "Sanctuary" (figure 110, Chapter 6).

Moving in the opposite direction texturally, we come to Tom
Hardy's use of clean-cut, broad, flat surfaces, best exemplified by
"Young Cow" (figure 41) of steel plate, cut and welded with the
oxyacetylene torch. The head and tail are cut from the center
sheet, which is the longest. The ears, legs and flanks of the animal
are cut from the two outer sheets, parallel with the center sheet.
The front legs are formed by making a diagonal cut to the lower
line of the belly and folding both triangular shapes inward until
they meet under the center sheet and support it. The hind legs are
formed by making a cut almost to the top of each outer sheet and
bending it back until its point touches the center sheet near the
tail, where it is welded in place. The ears are continuations of each
outer sheet and are formed by making a right-angle bend at their
narrowest point and welding their inner surfaces to the head form
of the center sheet. The angle of the ears and tail and the inquisi-
tive, forward thrust of the body are a knowledgeable translation
into steel of the angular grace of a young cow. Again, though this

Fig. 40. "Ostrich." Welded bronze. Luise
Kaish. (Sculpture Center)

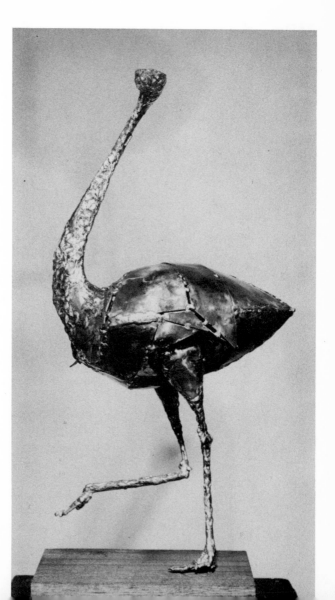

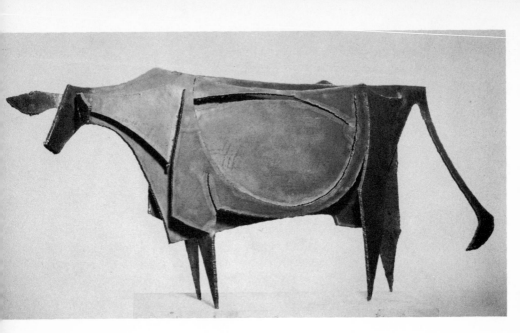

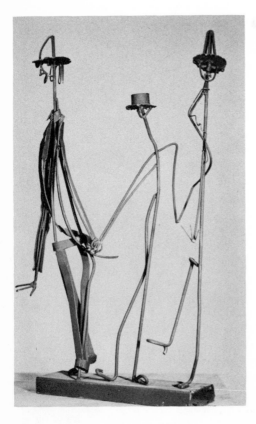

Above: Fig. 41. "Young Cow."
Welded sheet steel. Tom Hardy.
(Kraushaar Galleries) *Left:* Fig. 42.
"Three Drunkards." Steel. Juan
Nickford. (Sculpture Center)

particular example is welded, a lightweight version could be made with thinner pieces of metal soft-soldered together.

On a smaller scale, you might create a horse or deer of thin sheet steel, copper, brass or tin by cutting the metal with shears and a jeweler's saw of the type shown in figure 68, Chapter 4, which is a coping-saw frame equipped with a metal cutting blade. In order to use this type of saw on such a sculpture, it is necessary to drill or punch small holes at certain points for making the inside cuts, such as the sweeping, semicircular cut on the cow's flank, inserting the saw blade through the hole and then attaching it to the frame for cutting. Soft-soldering or silver-soldering could be used to make the few joins necessary.

This is not to say that the air of seriousness and permanence, the impressiveness of "Young Cow" could be captured with lightweight materials. Scale and weight are an inseparable part of the primary conception and a distinguishing mark of Hardy's sculpture. These comparisons are made not to bring creative work down to a do-it-yourself level but to point out that the best art is always the most fruitful source of ideas.

Juan Nickford's "Three Drunkards" (1951), figure 42, made of welded steel, is a carryover into heavier metals and a permanent technique of an idea anyone interested might find amusing as a soft-soldering or silver-soldering experiment. Nickford has deployed rods and flat strips so that their looping, droopy, entangled lines and uncertain angles are highly expressive of the tentative posture and dishevelled apparel peculiar to drunken camaraderie.

In his satirical human figures Richard Stankiewicz has found a unique use for junk. He is a sculptor who can put life into the most useless, utterly decrepit cast-off metal objects such as the bolt, section of geared wheel, door latch and sundry ruined hardware welded to produce the correctly named "Kind of a Man" (figure 43). Combining this approach with an unlimited supply of such defunct parts, we could create, by soft-soldering or silver-soldering, any number of interesting figures or abstractions similar in feeling to "Kind of a Man," "Mythological Story" (figure 12, Chapter 1), or "Committee" (figure 107, Chapter 6). Welding is not necessary for constructions such as these, but Stankiewicz uses welding for everything from "Abstraction" (figure 84) to "The Secretary" (figure 108, Chapter 6) because welding has an almost unlimited range of application. Most of his work is on a large scale which requires welding, but he finds it convenient to use the welding torch for his minor, spur-of-the-moment sculpture as well. Our technical concern here is soldering, with which smaller-scale sculpture using lightweight metal can be created; the subject of welding is discussed in Chapter 6.

Soldering is divided into two classes—soft-soldering and hard-soldering. Hard-soldering is covered in Chapter 4.

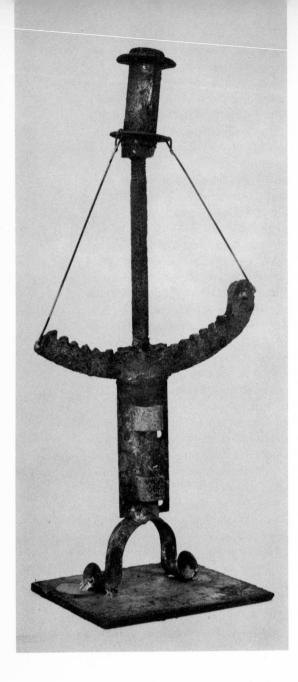

Fig. 43. "Kind of a Man." Welded steel and iron. Richard Stankiewicz. (Hansa Gallery)

Soft-soldering is the name given to the process of uniting metal parts by means of fire or heat through the use of a third metal, the solder, when only a low degree of heat can be applied to the metal. The process is commonly known as "tin soldering." The solder is a combination or alloy of lead and tin. Fifty per cent of each is the most usual alloy, being known as half-and-half solder. Special low-melting solder is made by adding bismuth and cadmium. Solder in wire form is the handiest.

Metal parts to be joined must be clean and free from oxides. Oxidation is guarded against by the use of a flux. Zinc chloride (muriatic acid with zinc added) is the best flux to use on copper and brass, but prepared soldering paste may be purchased at any hardware store and is much easier to handle. "Nokorode" soldering paste can be obtained in small tins and will last indefinitely. It works freely on galvanized iron, lead, tinned steel and other metals.

There are two methods of soft-soldering—with a gas blowpipe (or Bunsen burner), or with a soldering iron (figure 39). The small projecting tube at the side of the gas blowpipe at left of figure 39 is fitted to one end of a length of flexible hose and attached at the other end to a household gas outlet. The gas comes out the curved end and when lit is directed at the work by blowing lightly and steadily at the straight end. The parts to be joined may be laid across a tripod stand, set in a vise or vises, held with spring clamps in a jig devised for the work being done, or tied together with an iron binding wire, made especially for this purpose, which resists solder. Once the two pieces are in postion they may be joined, using the blowpipe, by the following method:

1 Apply flux to the joint.

2 Heat the work by directing the flame at the joint until the flux boils and crystallizes (a matter of a few seconds).

3 Apply the flux a second time.

4 Heat the work again.

5 Withdraw the flame quickly and lay a small piece of wire solder at the joint.

6 Direct flame at joint until solder melts and flows into place.

It is very important to be prepared to do the soldering quickly, because oxides form rapidly in the process of heating and solder does not flow on an oxidized joint. If the solder does not run, it is most likely due to the oxidation of the metal—in which case apply more flux. It may also be due to insufficient heating. The metal itself should be warmed before soldering and the soldering should be done in a draft-free area for best results. The following technique is used for the soldering iron:

1 Apply flux to the joint.

2 When the soldering iron is hot, dip the point of the bit into the flux.

3 Apply a little solder to the point of the bit (if it is clean and hot enough, a blob of solder will adhere). The bit may be cleaned (after heating) with a piece of fine sandpaper or a wad of coarse steel wool.

4 Apply the bit to the joint, moving it slowly along the joint until the solder melts and flows into place.

Careful preparation, well-fitted joints, quick application of heat and generous use of the flux are essential for a good job.

A little experimentation will show how easy it is to soft-solder, either with a blowpipe or soldering iron. Manufacturers' instructions are also usually given with soldering-iron kits sold at hardware stores. Check any special advice the manufacturer may give for operating his particular equipment.

Try soldering a few scraps of lightweight metal together first, then go to work on your metal sculpture. A simple project like "Clouds and Mountains" (figure 44) would be an ideal starter for anyone who has never done any soldering before.

One word of warning: while almost any light metals—sheets, rods or wired of tinned metal, copper, brass, or galvanized iron—can be soldered together, there are some that do not solder well, and one—aluminum—that does not solder at all. No metals can be soldered to aluminum, and two aluminum pieces must be welded together for a satisfactory joint. Also, soft-soldering is unsatisfactory for heavy metals as it will not form a joint strong enough to keep the two pieces from falling apart under their own weight.

"Clouds and Mountains" was made especially to illustrate the imaginative use of scraps. None of the pieces used was specifically cut out for this composition. All were chosen from a heap of discarded mobile pieces in the studio. Reducing the idea of clouds and mountains to its simplest terms, we have irregular ovals representing clouds and polygons representing mountains. Nails and straight pins do very nicely as rain. Raindrops were made by dropping molten solder from above. The solder splatters exactly like rain on a window pane and will adhere to the metal. A friend remarked that the effect was somehow Japanese, and it occurred to me that the forms I have enjoyed so often in Japanese prints were lurking somewhere in the back of my mind and provided the germ of an idea. The metal is unpainted, but the grayish, silvery surface with overtones of metallic blues and lavenders and reddish-brown

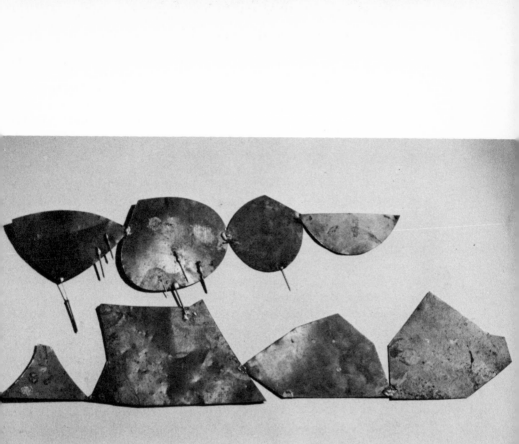

Fig. 44. "Clouds and Mountains." Tinned metal, nails, and straight pins. John Lynch. (Photo: Herbert Skoble)

areas of rust have a very delicate water-color quality which complements the suggestive power of the elementary forms. This is literally "making something out of nothing," and if you enjoy working with metal you will see possibilities for such impromptu efforts everywhere.

Studying the reproductions of the works of modern painters, such as Miro, Picasso, Klee, Braque—or, better still, visiting a museum of modern art—will stir up your imagination and enthusiasm for creative work in metal. The drawings and paintings of Paul Klee are a series of exquisite perceptions which reinterpret everyday objects such as the fish, the sun and moon, the glass and flower and the plant forms of "Around the Fish" (figure 45) in such a way that, divorced from utility, they become abstract, universal and fixed in the little cosmos which Klee has prepared for them. Klee is also preoccupied with magical and mystical phenomena, as in "The Witch with the Comb" (lithograph, 1922), figure 46. A curious method is employed to make an unreal figure real, and vice versa. Its power of suggestion derives from Klee's use of two abstract motifs—the scroll and the arrow, which are opposites in form and psychological content. The heavy black arrows, used as hands pointing downward, are the powerful symbol of force and black magic at which the figure hints. The figure itself is composed of a series of scrolls and variations which form the garments and hair. These convolutions create a false impression of three dimensions. They turn back on themselves and serve both as flesh and clothing. Watch children playing a game in which they not only pretend, but make solemn arrangements with one another as to how and what they will pretend, and you will see the barriers between real and unreal broken down without a moment's hesitation. One or two steps backward towards the primitive and the most civilized man is willing to endow the inanimate with supernatural and quasi-magical powers such as the objects seem to possess, in "Around the Fish," or to believe in witches and ghosts.

Looking at Klee's work is rather like being a spectator at an American Indian ritual dance. The symbols are not always clear, we do not always understand the significance of the dancer's movements, but there is no doubt whatever in our minds that the dance has a vital and important "point." The aura of meaning is projected beyond the actual material representation and creates an excitement very much like the stimulating tingle felt in the atmosphere before a storm. It is this magnetic current emanating from Klee's art that sparked the idea for "Tiny, Terrible Ruler" (figure 47). This sculpture was not modeled on any particular work, but was made in response to the many overtones and reverberations set up during a study of Klee's paintings and drawings, and employs a technique simple enough to suggest a similar beginning project.

As I have suggested before, no very ambitious projects can be

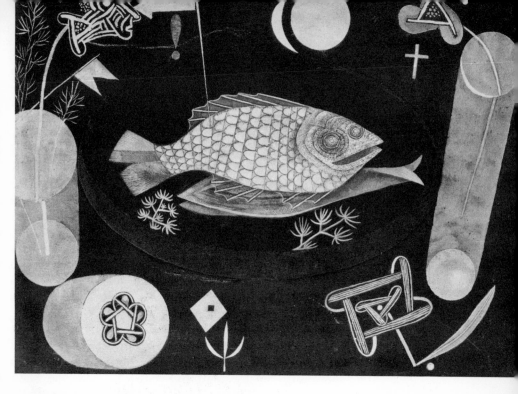

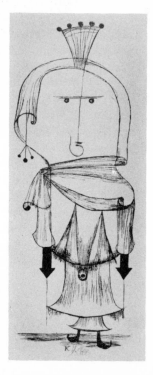

Above: Fig. 45. "Around the Fish"
(1926). Paul Klee. (Museum of
Modern Art) *Right:* Fig. 46. "The
Witch with the Comb" (1922). Paul
Klee. (Museum of Modern Art)

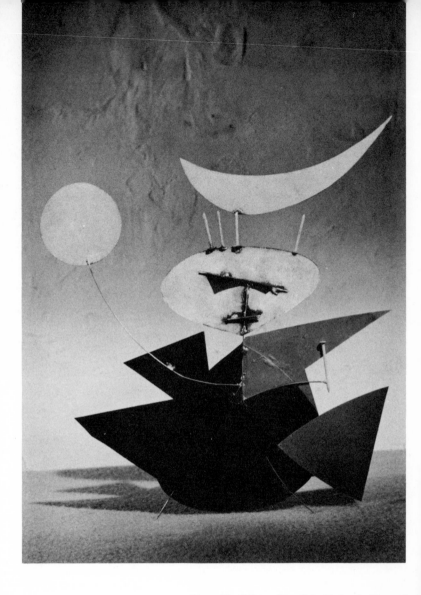

Fig. 47. "Tiny, Terrible Ruler." Tinned metal and nails. John Lynch. (Photo: Herbert Skoble)

realized with lightweight materials. However, all the abstract principles of design—form, proportion and spatial relationships—should be observed from the beginning. Merely because the sculpture is light and simple it need not be cute, precious or insignificant. "Tiny, Terrible Ruler" is made entirely of .012-gage tinned metal and 18-gage galvanized iron wire plus a few common nails. It is soft-soldered with a soldering iron and put together in the manner of a collage—that is, the pieces are cut out and "pasted" together with solder. It is approximately 11 inches high, yet due to the juggling of proportions, it has a serious air and a suggestion of larger scale. The disproportionately large circle held aloft at the tip of the thin wire arm and the crescent atop the crown made of nails are strong, positive forms, dramatizing and completing the composition in areas that might have been resolved more timidly. "Tiny, Terrible Ruler" is painted in theatrical shades—alizarin crimson and vermillion for the royal robes, zinc white for the face (with certain areas around the mouth and eyes ignored in favor of the rusted metal) and cadmium yellow for the orb, crown and nail scepter—a color combination entirely in keeping with the rather bizarre air of this sculpture.

"Sun and Boat" (figure 48), another very simple construction, is a sort of mobile-stabile or stabile-mobile, whichever you prefer, made of .012-gage tinned metal, 18-gage galvanized iron wire, and several nails. It is a two-dimensional construction designed to hang and revolve in the air on a nylon thread tied midway around the large nail on the left side of the circle. The hull is joined to the sail with a short length of wire soldered at each end. The sail is in two pieces, the dark line slightly to the left of center showing where they are joined. The pieces overlap and add a little touch of realism to the sail. The top corner of the sail is joined to the sun form by one of its wire rays, soldered at each end. The other rays are made of several small nails of different size and short lengths of wire. The circle at the outermost edge repeats the form of the hollow center of the sun and gives emphasis and added interest to the composition. There may at first seem to be no logical reason for adding this circle, but if you cover it with your hand you will see how its absence detracts from the total effect.

This brings up a point concerning composition. Whenever you think you have finished a piece of metal sculpture, try adding just one more piece—usually a variation on one of the elements in your composition. The small solid disc in "Sun and Boat" might be thought of as a positive variation on the negative, hollow center of the sun. Move the piece around and observe its effect before adding it. If you decide not to add another piece after this experiment, you will at least be more certain and satisfied that your idea has been developed as fully as possible.

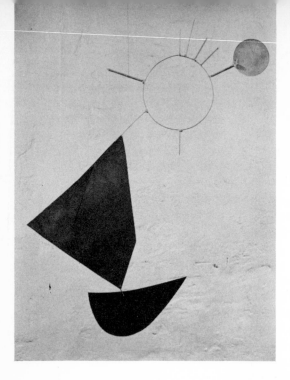

Left: Fig. 48. "Sun and Boat." Tinned metal, nails, and wire. John Lynch. *Below:* Fig. 49. "Votive Object." Tinned metal, nails, and galvanized iron wire. John Lynch. (Photos: Herbert Skoble)

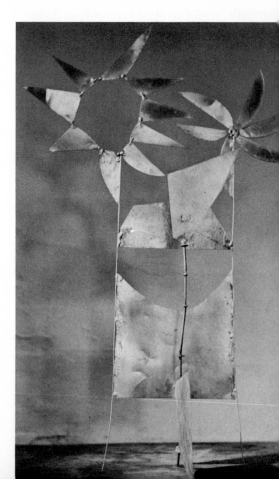

"Sun and Boat" is painted with oil paints. The hull is medium grey. The sail is painted in an impressionist manner by dabbing blue, green and white onto the surface and patting the paint with a small soft-haired brush until it is distributed evenly, giving a soft, hazy, very atmospheric effect. The sun and its rays are painted a light, bright yellow and the sun spot is a dazzling white. Whenever paint is used, it is always a means of balancing, strengthening, unifying or dramatizing a composition, and should be employed with this in mind.

"Votive Object" (figure 49) is also made of .012-gage tinned metal, 18-gage galvanized wire and several nails, soft-soldered. It is 24 inches high and 17 inches wide. A few simple tricks are involved in its construction. The pieces of the open-center, starlike form are soldered to one another by means of "bridges" of very fine (26-gage) tinned copper wire. Quarter-inch lengths of this wire have been laid across each pair of contact points and soldered on both sides. I did not want the points to overlap, since this would have destroyed some of the delicacy and crispness of outline, and would have been mechanically more obvious.

Another trick was that of not cutting the wire until after it had been soldered in place. Such short bits of wire are picked up as the iron is removed from the work, and are all but impossible to manage except with tweezers and extreme patience. Also, a length of several inches remains cool enough to be held at the other end with the bare hand. Large pieces are always easier to handle and this practice of first cutting and then soldering has a great many obvious applications.

The six points of the other star shape in figure 49 are joined at the center to a small ring formed of 18-gage wire. These pieces were laid in position on the work table, the ring placed on top of their center points and all six soldered at the same instant, the ring acting as a small pool for the solder. The triangular piece atop the column of nails is attached to the piece directly behind it by means of a length of wire soldered at right angles to both shapes. The column of nails supporting this shape was built up by placing the bottommost nail in the vise, getting a large drop of solder to adhere to the upper surface of its head, dipping the heated point of the nail to be placed above it into the flux, and pressing this point into the still liquid solder, holding it with pliers until set. The process was repeated, movng each nail down into the vise for steadiness.

The metal used for "Votive Object" was deliberately chosen from among odd scraps of tin that had been lying about on the work table for some time. It was discolored, scratched and rusted in places. However, when rubbed with steel wool, these irregularities were smoothed down, partly obliterated and blended. The result is an interesting, antique patina, quite appropriate to the mood of the work. You will find that steel wool will become a very

useful part of your equipment if you work with old metal. And to prevent future rusting of your tin sculpture, you can spray or paint it with clear plastic or lacquer.

Objects such as lanterns and chandeliers are not, of course, metal sculpture but, like the unsoldered utensils in Chapter 2, are introduced here to suggest things you might enjoy making for your home—for a change of pace, and toward practical ends. Modern adaptations will undoubtedly suggest themselves to you as you study the illustrations.

The "Lanterns" shown in figures 50 and 51 are early eighteenth century American. They were made by the thousands from tinned sheet metal, soft-soldered as described earlier in the present chapter. Attractive but not particularly refined examples of craftsmanship, they are nevertheless good projects for the beginner to copy. The millions of tin containers produced today by machine are stronger and neater, but without half as much character.

As a simple project, lanterns offer the chance to combine good design with ready-made components. The round lantern, for example, might be made from a tin can of any size by cutting out four, five, or six sets of double panes like those on the lantern in figure 51. The top might be made from a funnel (from which the stem had been removed) of the same circumference as the top of the can, or from a Jello mold soldered to the top edge of the can. The rectangular lantern can be made from a wax, turpentine, or olive-oil container. The two-tiered vent can be made from strips of perforated metal, the two discs cut to size and soldered in place. The door or all four sides can be punched in innumerable patterns with a chisel and center punch, or a door can be made from one side of a food grater. Worn-out or broken kitchen utensils are a good source of components that may be combined with the inexhaustible supply of tin cans to produce lanterns and other decorative objects.

Simple bending, twisting, and molding of tin can be done with your hands, with the aid of pliers, or with the use of a vise for holding a piece of metal steady. Square folds can be made over the straight edge of a workbench. And sooner or later as your interest and output grow you will probably invest in an anvil. Anvils are useful for molding or hammering out rounded shapes of tin. A scalloped shape like the lid of the lantern in figure 51, for instance, might be made more easily over the end of an anvil, although it is also possible to clamp a planishing stake (see figure 67) or a metal rod in a vise. If a rod is used, its end can be extended far enough so that the tin can be molded over it to make the scalloped design. Usually the metal sculptor improvises as he goes along, adding such tools from the hardware store as occasion dictates.

Undoubtedly one of the reasons for the charm of the antique two-tiered chandelier (figure 52) is that its maker took for his

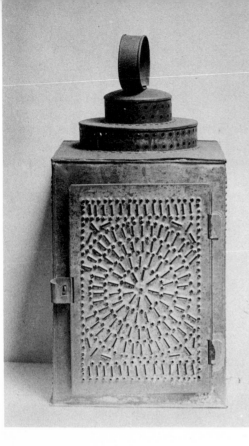

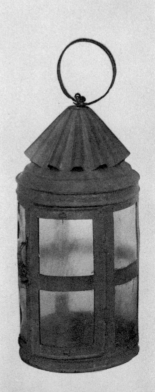

Above: Fig. 50. Lantern. Tin. American; 18th century. (Cooper Union Museum) *Right:* Fig. 51. Lantern. Tin. American; 18th century. (Cooper Union Museum)

model a much more costly crystal chandelier of the period. However, he did not allow the simplicity—one might almost say the meanness—of his materials (tin and iron) to spoil his appreciation of his model's proportions. There is probably much to be said for the very limitations imposed by the materials and techniques available to this craftsman. These limitations are also partly responsible for the clean lines and forthright air of this provincial interpretation of elegance. A comparison between this handmade and entirely functional lighting fixture and some of the mass-produced, cast-iron fixtures of the Victorian era—or even the quite hideous modern lamps, produced at a time when mass-production methods have been brought to a pitch of perfection—should convince anyone that a sense of proportion is far more important than an army of tools or a vast selection of materials.

Other examples of decorated utilitarian objects that can be made of tin and soft-soldered are shown in figures 53 and 54. The variety of Mexican tinwork is a tribute to the ingenuity of its craftsmen. Even though it is now "folk art gone commercial," it still retains a great deal of charm because it is produced by hand according to well-worn patterns. Sheet tin, metal shears, various dies, punches, hammers, pliers and soldering comprise the means of production. The tree candlestick (figure 53) is a good example of a simple idea, successfully elaborated. The following analysis of its construction may prove helpful.

The base, though probably specially formed for this design, might be made from a discarded canister cover. The trunk is formed from sheet tin rolled into a cone shape. The edges are folded back on themselves, one turned inward and the other outward.

The resultant interlocking S is hammered shut against a rod run lengthwise through the trunk. A hole is then cut in the center of

the base and the trunk pushed through from the underside, leaving about a half inch under the base. Several cuts (using tin shears) are made in this remainder and these sections are bent up against the underside of the base and soldered into place. For a neat job, the circular joint on the upper side of base is soldered all around, so that the trunk appears to be growing out of the

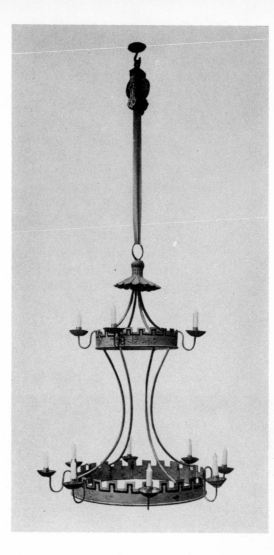

Fig. 52. Chandelier. American; 18th
century. (Cooper Union Museum)

base. Each of the six tiers contains four leaves or branches in the form of an elongated triangle; each edge is snipped with the metal shears for a leafy effect. Begininng with the bottom unit, these metal leaves are attached to the trunk by making a hole in the center of each unit and fitting it into its proper place on the trunk. To make the hole, draw a circle of the proper diameter in the center of each tier. Punch a smaller hole in its center, insert the tip of the metal shears and make a spiral cut outwards until a hole of the necessary circumference is obtained. Each tier is soldered into place with a few drops of solder on its underside. The hollow cone forming the trunk is a strong as well as graceful shape and supports the featherweight foliage and actual candle holder. The holder is made by forming a cylinder about ¾ inch in diameter with overlapping edges as described above and soldering to a disc of tin, which is then soldered to the top of the trunk.

Careful scrutiny of the masks in figure 54 will enable the reader to figure out other simple methods of construction. The seeming complexity of design is due mostly to the exuberantly decorated surfaces, the repetition and exaggeration of simple forms, and the glittery quality of new tinned metal.

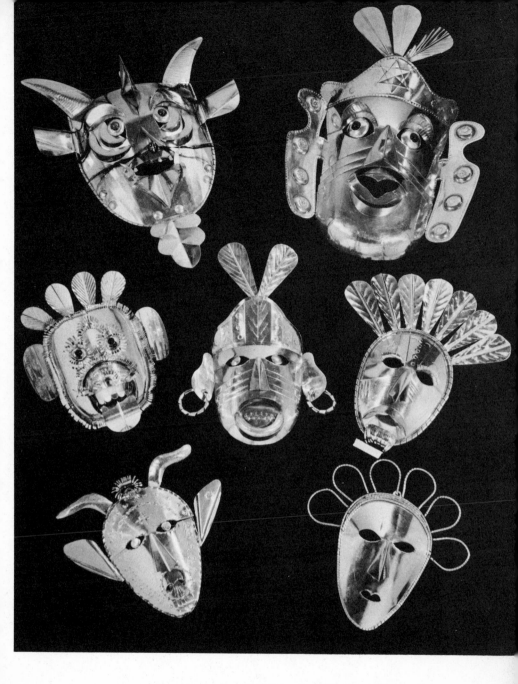

Opposite page: Fig. 53. Candlestick. Tin. Mexican. (Fred Leighton, Inc., New York)
Above: Fig. 54. Masks. Tin. Mexican. (Fred Leighton, Inc., New York)

4 SILVER-SOLDERING

SILVER- OR HARD-SOLDERING IS USED WHEN AN EXCEP-
tionally strong, neat and permanent joint is desired,
as required by silversmiths and jewelers. Industri-
ally, the process is known as brazing and is widely
used to join small parts. The cylinder for the com-
pressed-gas torch shown in figure 55 is manufactured
in three parts and joined with silver solder.

For the amateur, the most convenient and economi-
cal source of a flame hot enough for silver-soldering
is generated by the torch in figure 55. Other meth-
ods, depending upon circumstances, are currently in
use. Very small objects can be silver-soldered with
the flame of a Bunsen burner or alcohol lamp, directed
at the work by blowing across the flame through a
mouth blowpipe—a long, thin curved tube. A foot-
powered bellows or motor-driven blower may be used
with household gas and a torch similar to that in fig-
ure 56 for larger projects. Don't be put off by sup-
posedly rigid technical requirements. Soft-soldering,
silver-soldering and welding simply require succes-
sively higher degrees of heat and, except in the case
of welding, if these requirements can be met by semi-
improvised methods, they will do the work satisfac-
torily.

Adda Andersen, well-known silversmith, is shown in figure 56 using a torch which combines ordinary household gas with air under pressure, from a small compressor. She is heating a bowl preparatory to soldering its handle. In her left hand she holds a rod of silver solder, one end of which has been dipped in flux. The bowl is resting on a bed of lump pumice, which absorbs and stores heat from the torch, helping to keep the work at uniform temperature. The pan is on a revolving stand, so that the work may be turned in any direction without being touched. Fireproof bricks, tripod stands and wire grids for other types of work are seen at the back of the table. This torch and other equipment is of the type usually employed by silversmiths and jewelers who must perform hundreds of silver-soldering operations daily.

For occasional work, of course, not all of this equipment is necessary. The portable torch, wire solder and flux (figure 55) used with homemade rigs are more than adequate for silver-soldering light-weight copper, brass, silver and steel sheet, wire and rods of the type that would be used for metal sculpture, such as Rickey's "Sailing Ship" (figure 59) or Hardy's "Billy Goat" (figure 61).

The torch shown in figure 55 weighs only a few pounds and is very easy to handle. These torches are available in hardware stores, jewelers' supply houses and hobby or craft shops. They represent an investment of less than ten dollars and are often available in kits with several interchangeable tips for cutting and annealing as well as soldering. Complete instructions for attaching the tips and operating the torch are supplied with each sale.

These torches can be comfortably and safely used in an apartment or house, in the kitchen, cellar or garage, taking normal precautions against fire. The torch contains a supply of liquefied petroleum fuel which will burn for 12 to 15 hours, depending on the type of work done with the various tips. This fuel supply is a much bigger bargain than it sounds, since most soldering operations require no more than a few minutes of heat at a time. The cylinder, when used, is discarded (it cannot be refilled) and a new one must be purchased for use with the same set of attachments.

The small jar illustrated in figure 55 contains a flux which serves the same purpose as the paste used for soft-soldering—to stop oxidation of the metal and make the solder flow freely. It can be used when silver-soldering copper, brass, bronze, nickel, steel, stainless steel, Monel and other ferrous and nonferrous metals. If it dries out, a small amount of water may be added to restore it to a working consistency. The wire silver solder (figure 55) comes in many gages and is usually sold by the ounce. One ounce will actually do a great deal of soldering, since very little need be used to produce a strong joint.

The soldering procedure is the same as that outlined in detail for

Above: Fig. 55. Portable torch for silver-soldering, flux, and silver-solder in wire form. (Photo: Herbert Skoble)
Below: Fig. 56. Heating a silver bowl with a torch, using household gas and compressed air, preparatory to soldering. (Photo: *The New York Times*)

soft-soldering, and no more difficult. One amazing thing about these processes, including oxyacetylene welding (dealt with in Chapter 6) is that no technical knowledge is really necessary of what is taking place chemically or physically. These tools, developed for industrial purposes, are so efficient that even an absolute beginner will probably succeed at the very first try. There are however, a few important points which deserve mention, no matter what silver-soldering equipment is used, because soldering troubles usually can be traced to an oversight of one of them.

1 Location of Soldering Equipment

Color is your indication of heat. Because heat colors cannot readily be distinguished in a bright light, select the darkest corner of the room for your soldering, or shield off the light for this operation.

2 Cleaning

The pieces to be joined and the solder must be free from any oxides, dirt, or grease. These may be removed with scraper, file, crocus cloth, or polish buff, depending upon the circumstances.

3 Flux

Apply the flux with a brush to joint areas to be soldered as well as to the pellets or strip of solder. Flux forms a protecting coat, allowing the solder to flow into the joint. For best results the flux must be entirely fluid below the melting point of the solder.

4 Preheating

Using a soft blue flame, concentrate heat on the part with the greatest weight, bringing both parts to soldering temperature at the same time.

5 Balling of Solder

Balling of solder may be caused by improper fluxing, or the presence of dirt. It may also be caused by insufficient heat or a flame concentrated on the solder pellets rather than on the silver.

6 Flow Points

A thorough understanding of the following table of flow points will aid you in your soldering. Color, your indication of heat, shows first at the ends of wire and the edges of sheet silver.

900° F.—First visible red

Handy Flux
 is fluid at 1100° F.

. 1200° F.—Dull red

"Easy" Solder
 is fluid at 1325° F.

"Medium" Solder
 is fluid at 1390° F.

Borax
 is fluid at 1400° F. 1400° F.—Cherry red

"Hard" Solder
 is fluid at 1425° F.

"IT" Solder
 is fluid at 1460° F.

1500° F. Never heat silver above this
temperature.

Sterling silver must not be heated above 1500° F. because it begins to break down above this point. It is liquid or flowing at 1640° F. Fine silver is liquid at 1761° F.

A good example of how the portable torch and silver solder can be put to practical uses is shown in figure 57. The base of this lamp is made from a small silver-plated canister and the shade is of antique glass, dark green on the outside and white on the inside. I found both in an antique shop, the canister first. I had decided to buy it since it cost practically nothing and I liked it, though it was utterly useless. I was poking around the shop with the canister in one hand when I came across the shade. In one motion and without thinking, I picked up the shade and held it over the canister. The congruity of the two forms—their color, texture and size—immediately suggested a lamp. Feigning indifference, I got the shade for as little as the base. Both cost me less than one dollar. Three short lengths of steel rod, bent to form the supports for the shade and silver-soldered to the neck or collar of the canister, and a porcelain socket of the adjustable display type (which, when trimmed a bit with the metal shears, just happened to fit perfectly) and about a half hour's work combined to produce a unique and, I think, rather charming lamp.

A five-branched candelabra is a very inexpensive luxury when made of Jello molds and steel wire such as the one in figure 58. This is another good "first project" using silver solder. The molds were bought at a thrift shop for a few pennies each. The frame is made of 12-gage steel wire. (Copper or brass wire of the same gage and strength could be substituted for steel.) A thinner or

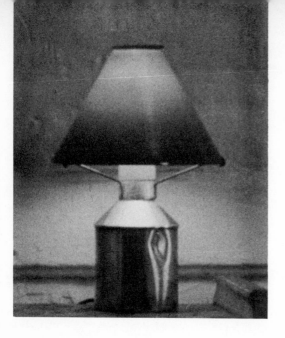

Left: Fig. 57. Lamp. Silver-plated canister with glass shade. *Below:* Fig. 58. Candelabra of gelatine molds with 12-gage steel wire frame. (Photos: Herbert Skoble)

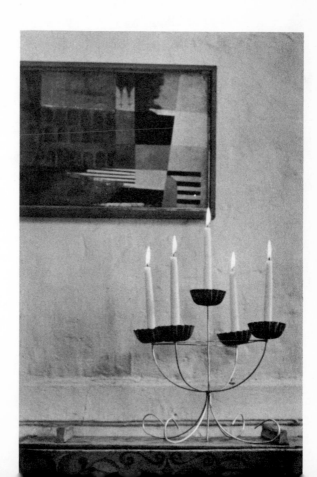

Fig. 59. "Sailing Ship." Stainless steel sheet metal, bar, and rod. George Rickey. (Kraushaar Galleries)

softer wire cannot be used because the design depends partly on the strength of the wire, which must span a distance of about a foot above and below the center joint, and support the molds and candles. The four curved shapes of the armature were obtained by bending the wire around empty cans of various sizes. The center rod is straight and the four arms are silver-soldered to it. These arms were held in place by fine wire while being soldered, the wire being left under the solder as part of the joint. A single length of 16-gage steel wire is bent to form four concave curves and pinched tightly around each of the four arms just under the molds. The center rod touches the table top, giving added support and completing the design. Votive candles in their glasses for outdoor use, or taper candles for more elegant indoor use, are equally effective. Holders for the taper candles may be made from sections of ¾-inch-diameter steel tube cut into one-inch lengths with a hacksaw and soldered to the inside bottom center of the molds.

An artist who has contributed much in recent years to metal sculpture and who uses silver-soldering extensively in his work is George Rickey. A perfect example of what he calls "Kinetic Sculpture" is provided by the "Sailing Ship" (figure 59). This ship is constructed of stainless-steel sheet metal, stainless-steel rod, and a hull fashioned from a solid steel bar. The sheet metal used for the sails is scored on alternate sides with a sharp instrument (awl, center punch, scriber, or ice pick) to give greater strength to the flat surfaces and to increase their decorative value by creating a light-dark relief pattern. Pieces of stainless-steel rod are silver-soldered to the top and bottom at approximately the center of each sail. They are filed or ground to a point and set into small tapered holes drilled into the horizontal rods of the rigging framework. Two methods are used to create the sockets into which these pivotal points are set. One is to drill part way through the rod, using two drills, the first slightly larger than the second. The other method is to build up sockets from a drop of silver solder which is then drilled in the same manner, the drilling being continued part way into the rod. This makes a much deeper socket with a small neck projecting at right angles to the horizontal rod, and gives greater security to the pivotal points at the extremities. These sockets can be seen more clearly in figure 59 in the topmost pivot point, in the top pivot point of the bow sail, and the pivotal point of the hull on the underside of the bowsprit.

There are many well-thought-out and nicely engineered details in the seemingly simple construction of the ship. For example, the two small triangular sails fore and aft on the second row of the construction are soldered directly to the framework. They reinforce its rigidity, keep firmly in place the open ends of the horizontal bars into which the top pivotal points of the fore-and-aft sails on the first row are set, and act as wind-catching vanes.

The hull of the ship is ingeniously connected to two sets of pivotal points. There is one of these on each side, amidships, connected to a horizontal loop completely encircling the hull, which in turn supports the entire superstructure on the pivotal points at the bow and stern. This arrangement duplicates the pitch and roll of a sailing ship with fantastic realism. The heavy solid steel hull functions as a pendulum, prolonging motions started by a light touch or a puff of air. The sails, pivoted slightly off-center, move with a very real eccentricity and the whole mood of a ponderously heaving sailing ship, with creaking masts and spars and an uncertain and hesitant grace, is marvelously recreated.

MATERIALS NEEDED

Rickey uses the following materials in most of his work:

Sheet Metal

"Half hard" brass .010" thick \times 6"
Stainless steel .010" to $\frac{1}{8}$" thick
Aluminum from .015" to .060" thick
Copper

Rods

Cold rolled square "key" steel rod from $\frac{1}{8}$" to $\frac{5}{16}$"
Cold rolled round steel rod from $\frac{1}{16}$" to $\frac{1}{2}$"
Brass and aluminum rod in the above sizes

Bars

Steel, brass and aluminum $\frac{1}{8}$" \times $\frac{1}{4}$" to $\frac{1}{8}$" \times 1"

Wire

"Music" (highly tempered) wire from .010" to $\frac{1}{8}$"
Stainless steel from .010" to $\frac{1}{8}$"

For pendulums, heavy steel bars of various sizes and sometimes lead cast in suitable shapes are used.

Tools

Hack saws, metal shears and chisels
Drill press, grinder, vise
Files, punches, taps and dies in a number of sizes
Ball-peen and soft-face hammers
Anvil made of a chunk of steel rail
Rulers and squares
Felt-nib pen
Micrometer for checking metal thicknesses and wire gages in relation to drills.
Gas torch for silver solder—either a portable Prepo or natural gas with a compressed air torch (occasionally acetylene Prestolite)

Because of their expense, silver and gold are metals you should consider using only after considerable experience with metal sculpture. For objects to make in precious metals we have abundant examples from the past and present. I recommend a study of the folk arts particularly, and the gold and silver objects made thousands of years ago in Asia and South America. You can see these in the museums. On our own shores, the Indians have shown us what attractive jewelry can be made without expensive tools. So, although you wouldn't choose to work in silver or gold for your first metal working project, you don't have to be a Cellini or a Fabergé to make simple designs that are in good contemporary taste.

In Peru, silver was more plentiful than iron or tin. For centuries before the arrival of the Spaniards, Peruvian Indians had used silver and gold for sculpture and for useful, decorative and ritual objects. The silver "Alpaca" (figure 60) is the hollow style of the Incas of Peru. The awareness, expressed realistically but very subtly by the flaring nostril, wide-opened eye, sharply pricked ear, and the whole rakish stance of the animal is superbly combined with the severely abstracted ridged silver sheet which represents the long, luxurious coat of the alpaca, and puts the emphasis, as in all Inca work in gold and silver, upon preserving the beauty of the material.

Tom Hardy was undoubtedly influenced by an ancient design when he made the silver "Billy Goat" shown in figure 61. This is a rigidly stylized construction. Four sheets of silver with raised geometric patterns successfully recreate the raffish body and wagging beard of a billy goat with remarkable economy of materials and methods. The voluptuous, velvety quality of the alpaca's coat is an entirely appropriate contrast to the flat, jazzily embossed sheets of the goat's coat slapped over the springy armature.

In both the ancient and the modern examples just mentioned, we find a masterly handling of sheet silver which vividly reflects the characteristic physical qualities of the two animals.

The "Armadillo" (figure 62) is another silver-soldered animal by Tom Hardy. Sheet silver and silver wire are used for the flexible and armor-plated portions of the armadillo's body. The anatomical details are very simply indicated and do not interfere with the visual impact of the simplified, characteristic body of this primeval animal.

Paul Lobel is a jeweler who also makes small, highly stylized silver sculptures. The "Assyrian Lion" (figure 63) is an interesting example of his technique. The two shapes of the body and head have been cut from a fairly thick sheet of silver with a jeweler's saw (a coping saw with a thin metal cutting blade, figure 68). The curving spine which continues as a tail and multiplies itself into features is formed from a narrow strip cut from a sheet of

Opposite page: Fig. 60. "Alpaca." Silver. Peru (Inca style). (American Museum of Natural History) *Below:* Fig. 61. "Billy Goat." Silver. Tom Hardy. (Photo: James B. Monson)

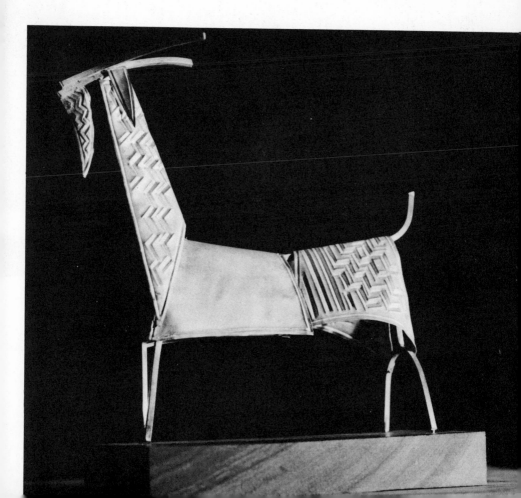

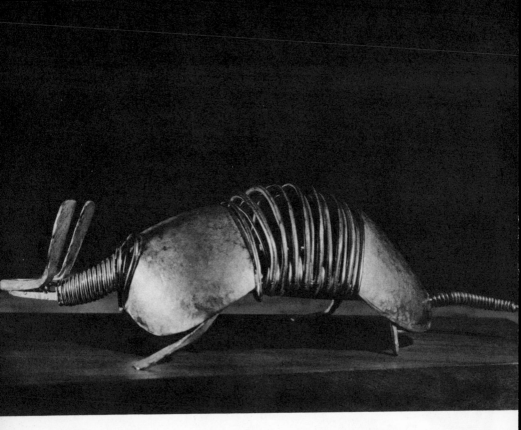

Above: Fig. 62. "Armadillo."
Silver. Tom Hardy. (Photo:
James B. Monson) *Opposite
page:* Fig. 63. "Assyrian
Lion." Silver. Paul A. Lobel.
(Photo: Douglas Grundy)

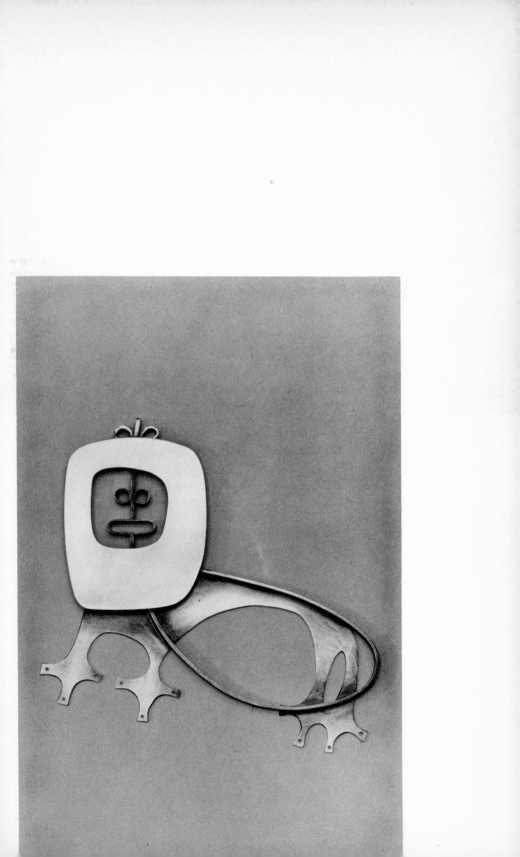

silver and set on edge between head and body and silver-soldered to both. The flat sheet and the strip on edge are two nicely balanced opposites which create a rhythmic counterpoint of forms. The lion could be worn as a brooch, or mounted on a block of polished wood and used as a paper weight, or used as a handsome ornamental device on a small wooden box.

The jewelry (figure 64) by Fred Farr, who is also an accomplished sculptor and metalworker, was shown in an exhibition of handwrought silver jewelry at the Museum of Modern Art. While most of these pieces are hammered and shaped from sheet and wire silver and soldered, simplified versions might be made in copper and brass. The ideas are charming and show skill and imagination. Merry Renk's star necklace and earring (figure 65) are cleverly designed and impeccably made. The lightweight, sprightly flower-stars are each formed from a single very narrow strip of silver sheet folded and bent back and forth with pliers and joined with links to form a flexible collar. A similar necklace could be made using silver, copper, or brass wire which would be easier to handle and attractive in its own right.

If you want to continue with jewelry as a hobby or possibly as a money-making venture, you will want to acquire, in addition to the silver-soldering equipment shown in figure 66, tools which will not only make your task easier but allow you to design and make more complicated jewelry. Jewelry making is a fine craft and, of course, constitutes a whole subject in itself. Naturally it interests many metal sculptors. Farr, Calder and Lassaw among others make jewelry for their wives and friends, using the tools, equipment and methods of metal sculpture. However, specialized tools may be purchased at jewelers' supply houses or hobby and craft shops, such as Allcraft, 15 West 45th street, New York 17, N.Y. Allcraft not only supplies hundreds of items of jewelry-making and craft equipment but will answer all craft questions by mail.

The tools and equipment illustrated in figure 66 are basic requirements for jewelry making. A detailed list of tools and equipment designed for each operation, which will considerably speed up work done in quantity, is given toward the end of this chapter. All of this equipment, as well as silver and other metals in standard gages, may be ordered from Allcraft or other jewelers' supply houses.

The tools arranged on the workbench in figure 66 include a vise, mallet, a coil of silver wire solder, a charcoal block, a jar of "handy flux," a scriber, a three-sided file, scissors, pliers, gas torch, jewelers' saw, draw tongs, crocus cloth, pickling solution in glass refrigerator jar, pickling tongs, and a soft-haired brush used to paint the metal with flux and to pick up tiny pieces of wire-form silver solder (which can be done easily when the brush is wet with flux). The tapered wooden block projecting from the front center edge

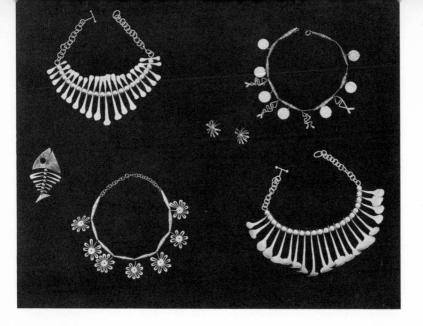

Above: Fig. 64. Jewelry. Sheet and wire silver. Fred Farr. (Museum of Modern Art)
Below: Fig. 65. Necklace and earring. Silver. Merry Renk.

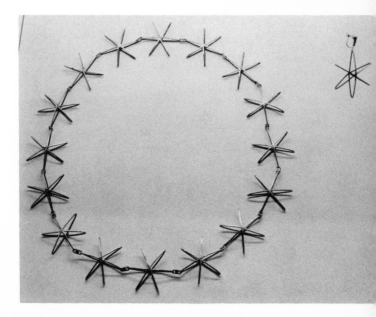

of the bench is called a bench pin and is used for sawing (as illustrated in figure 68) and filing, to steady the hands while performing such operations as cutting (figure 69), as a convenient surface for setting aside small pieces of metal to be assembled, and in dozens of other ways. Certain basic operations common to all metal working projects, such as sawing, bending, twisting, scribing, cutting with shears and soldering, are illustrated in figures 67, 68, 69, 70, 71 and 72. Additional information and further helpful hints are given in the captions accompanying these illustrations.

To pickle silver, after soldering, pick up the work with copper tweezers or copper wire only and drop into pickle bath (1 part sulphuric acid and 8 parts water). Leave work in the solution for a few minutes until silver is white, indicating that all oxides and flux have been removed. Rinse thoroughly in water and dry.

We need not be too fussy about gages and other dimensions when buying metal. It is not *wrong* to use 16-gage rather than 14 or 18. Whatever looks right *is* right. However, dealers use a standard system of gages for sheet metal, rod and wire of all kinds —copper, brass, silver, steel, etc. The smaller the gage number the thicker the sheet, rod or wire, and vice versa. After you have become familiar by sight with these relative thicknesses, you can confidently order by gage from a dealer or mail-order supply house. The gages and widths for silver sheet, rod and wire given below apply to all other metals as well, and are those most commonly used by craftsmen.

Fig. 66. Bench with equipment for fine metalwork.

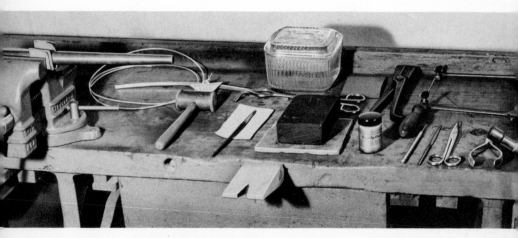

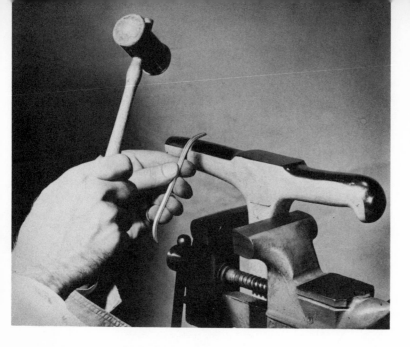

Above, right: Fig. 67. Bending operations are accomplished most easily and without damage to the metal by the use of a perfectly smooth, curved steel stake held in a vise attached to the workbench. The mallet shown is of leather and is strong enough to bend the metal without scarring it. *Above, left:* Fig. 68. When sawing, grip saw just firmly enough to guide it and take long, easy strokes, with saw in position as shown. Do not push. Saw cuts on the down stroke. The work is held firmly in a bench pin.

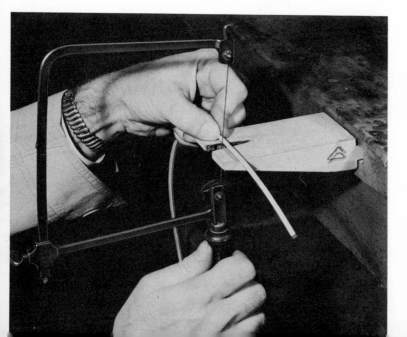

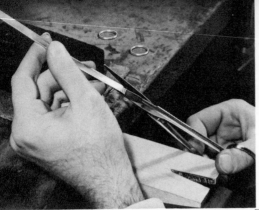

Fig. 69. Gages of soft metals as thin as this 26-gage silver strip may be cut with scissors.

Fig. 70. A simple decoration will enhance a plain surface. There are many patterns you may work out, bearing in mind that the decoration is secondary in an object whose structure is a thing of good proportion. You may make your guide lines with a scriber.

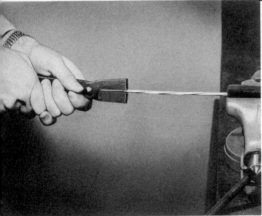

Fig. 71. Twisting with draw tongs. Twists will be evenly spaced if you pull with firm pressure as you rotate the tongs. If the metal hardens before enough twists are made, anneal it by heating to a dark cherry red. Air-cool or quench in cool water, then continue twisting. Saw off damaged ends, file ends perfectly round, and polish.

Fig. 72. To silver-solder, play a soft flame on and off the work for a few minutes, allowing the flux to evaporate slowly. Watch the color in the metal carefully. When the solder has flowed through the joint, withdraw the flame immediately and allow to cool. File away excess solder. The ring is held in a grooved charcoal block placed on asbestos. Charcoal intensifies the heat.

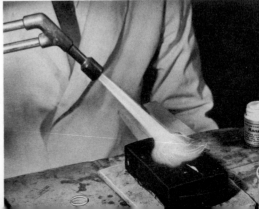

Sterling silver may be had in sheets, circles, strip and wire according to your needs. Although sterling silver is sold by the troy ounce, craftsmen find it more convenient to order it by dimensions. However, you must give all dimensions—length, width and gage, or thickness. If you order by the ounce, it is still necessary to give the gage and width. Unless otherwise specified, silver comes to you annealed or soft. It can also be supplied in various tempers with a spring quality for sections or units demanding strength but requiring no soldering, such as pin tongs and clips. These tempers are called *half hard, hard,* and *spring hard.*

SILVER SHEET

Sterling silver sheet is available in all standard gages and widths up to 15 inches, or even wider for special orders, but the gages given here are those most commonly used by craftsmen.

Blanks can be supplied in all gages and dimensions. Practical sizes are 12 \times 6, 3 \times 6, 6 \times 6, etc.

gage	recommended for
12	Very heavy rings and forged bracelets
14	Heavy rings and bracelets
16	Average rings
18	Lightweight pierced designs
18 to 26	Brooches, earrings, beads, buttons, etc.

CIRCLES

Following are the most commonly used circles for beads, buttons, and decorations: 26-gage—$1\frac{1}{32}''$; 24-gage—$\frac{1}{2}''$; 22-gage—$\frac{5}{8}''$; 20-gage—$\frac{3}{4}''$; 18-gage—$1''$. These small circles may be had in any gage and in a variety of diameters. The smallest is $1\frac{1}{32}''$. Practical sizes for boxes, bowls, etc. are $2''$, $3''$, $4''$, $5''$, and $6''$ circles in gages from 24 to 20. When ordering circles, specify both the diameter and gage.

WIRE

Although wire may be had in all standard gages, the following are most commonly used by handcraftsmen:

round	square	half round
9	8	$\frac{5}{16}''$ base
12	12	6
16	14	10
18	18	15
20		
24		

The above data, the detailed list of tools and equipment on page 96, and the excellent photographs illustrating some of the tech-

niques of jewelry making were kindly supplied by Handy & Harmon, 82 Fulton St., New York 38, N.Y., well-known manufacturers of silver and gold in every form and also makers of fluxes used industrially and by craftsmen. The firm will supply the name of a distributor in your state upon request.

LIST OF TOOLS AND EQUIPMENT

Here is a large general list for the construction of jewelry, from simple bracelets to more complicated pieces set with gems. If time permits, much of this equipment can be made. With additional stakes, hammers, and large files, you will have the right equipment for silversmithing, or making hollow and flat ware.

SOLDERING EQUIPMENT for Hard Soldering Only

Where city gas is available
Torch 11″ length, air tube $\frac{3}{32}$, gas tube $\frac{9}{32}$ used with blower or bellows

or

Small Blowpipe for chain work, used with Bunsen burner

Where city gas is not available
Tank or Bottled Gas with specially designed attachments

or

Blowpipe with alcohol flame

Wire Soldering Tweezers 5¾″
Flux—borax, borax slab, or prepared flux such as Handy Flux for Handy silver solders
Small Brushes for painting flux
Binding Wire, 3 sizes—32, 20, 16
Hollow Scraper 2″ blade
Tweezers 4½″ for placing small pieces

Pickle Jar (glass refrigerator jar with lid is ideal)
Copper Pickle Pan approximately 4″
Copper Tongs for pickle
Charcoal Block 3″ × 5″
Asbestos Soldering Block 6″ × 6″ Heating Frame and Asbestos Block to be used beneath it

POLISHING EQUIPMENT, Motor Driven

Electric Motor
Lathe Splasher 5″ wide, 9″ deep
Pumice, 1 lb. medium
Medium Felt Wheel 3″ × ½″ face
Brush Wheel

Rouge Cake for high polish
Cotton Wheel
Set Emery Paper Lathe Buffs
Medium Emery Paper
Fine Emery Paper
Burnisher 1½″ or 2″ straight blade

96

Crocus Cloth

Medium Emery Paper

Fine Emery Paper

Burnisher 1½″ or 2″ straight blade

GENERAL EQUIPMENT

Work Bench or Table

Bench Pin

Small White Pan for oxidizing solution

Potassium Sulphide for oxidizing, ¼ lb.

Saw Frame

Saw Blades—0 is about medium for jewelry work

Draw Tongs or Large Pliers for twisting heavy wire

Small Vise

Round File 14 mm.

Three Square File 14 mm.

Half Round Needle File 14 mm.

8″ Half Round File 4 cut (fine)

8″ Half Round File 0 cut

Leather Mallet

Ring Mandrel

Planishing Hammer

Raising Hammer

Ring Clamp

Hand Drill

Twist Drills No. 70, No. 60, No. 50

Chain Pliers

Half Round Nose Pliers

Flat Nose Pliers

Side Cutting Nippers

Shears 7″

Divider approximately 5″

Dapping Punches and Cutters

Dapping Die

Several metal sculptors and silversmiths have designed and made chess sets for their own use or to be sold through galleries and shops. Sidney Gordin has made several such sets to order, of which the set in figure 73 is representative. The symbols for the King, Queen, Bishop, Knight and Rook have been refined and unified visually. Using the squares of the chess board itself as his basic unit of design, Gordin has devised a series of variations on a theme. The Knight represented by an arrow is an especially brilliant choice of an unmistakable symbol—The Knight's lance immediately leaps to mind. The circle used only to denote the King makes this figure dominate visually as well as strategically.

Gordin's coolly stylized solution for a contemporary version of these antique figures should provide a provocative challenge to your own powers of invention. If you have been sufficiently inspired by the material so far presented to buy a torch and silver-soldering equipment, a chess set of your own design would be a most worth-while project and would make a very welcome gift.

In accord with the growing recognition of metal sculpture by private collectors and museums, and in keeping with the time-honored tradition of commissioning works of sculpture, the Towle

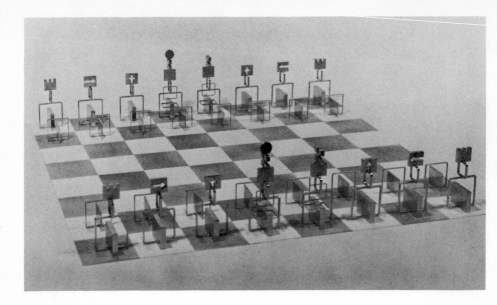

Fig. 73. Chess set. Steel-bronze and nickel plate. Sidney Gordin. (Grace Borgenicht Gallery)

Silversmiths recently commissioned eight sculptures in silver from contemporary metal sculptors. These eight works, having returned from a nationwide tour, now occupy a permanent place beside the company's collection of early American silver at its museum in Newburyport, Mass. Three of these sculptures are represented here. The silver-soldered sculpture of David Smith, Ibram Lassaw and Richard Lippold illustrated in figures 74, 75 and 76 are completely characteristic of their welded work in other metals, except for the fact that they and the other five sculptors chose to work on a much smaller scale than usual. This was their spontaneous reaction to silver—not because of its cost, but because silver has a delicate, intimate quality which does not seem appropriate for sculpture on a large scale.

David Smith's "Birthday" (figure 74) is 11 inches high and 22 inches long, while Lassaw's "Hathor, Egyptian Goddess of the Moon" (figure 75) is 10 inches high and 8 inches wide. Perhaps Smith's sculpture was inspired by the ceremonial elegance associated with silver. Lassaw's theme could not have been expressed in a more appropriate metal than silver, which is both feminine and nocturnal. De Rivera also contributed a fluid abstraction similar to that in figure 113, Chapter 6, which is typical of his flawless work. Another typical work in this precious metal is Lippold's

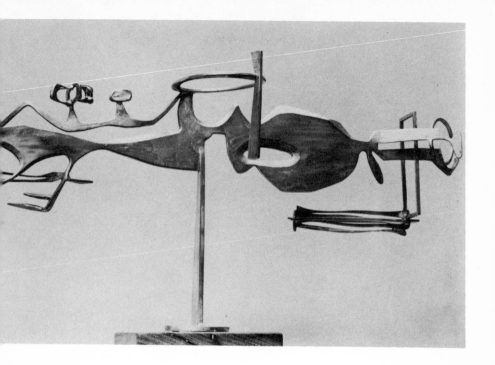

Above: Fig. 74. "Birthday." Silver. David Smith. (Towle Silversmiths, Collection) *Right:* Fig. 75. "Hathor, Egyptian Goddess of the Moon." Silver. Ibram Lassaw. (Towle Silversmiths, Collection)

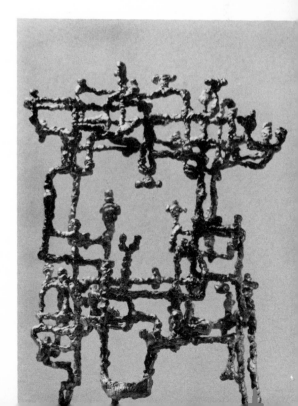

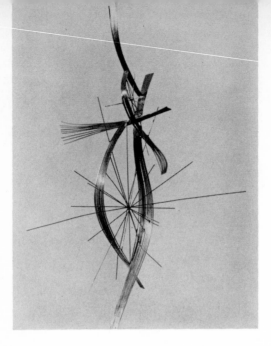

Fig. 76.
"Young Venus."
Silver.
Richard Lippold.
(Towle Silversmiths,
Collection)

"Young Venus" (figure 76), a construction fashioned of silver wire in a pleasurable response to the metal's loveliness.

Although we are accustomed to associating silver and gold with jewelry and precious useful objects, both lend themselves beautifully to abstract sculpture on a small scale and will probably be used more in future work as metal sculptors continue their search for new forms and new uses for traditional materials.

Julio Gonzalez, whose sculpture in wrought iron, "Woman Combing Her Hair" (figure 2, Chapter 1), took this revolutionary forward step in sculpture with the advantage of a well-grounded knowledge of metal working. He came from a family of Barcelona iron workers who specialized in decorative wrought iron of the type used for screens and candelabras in Spanish churches. Pablo Gargallo, his pupil and friend, learned the technique of working in wrought iron from Gonzalez and worked almost exclusively with it, producing such justly famous works as "Picador" (1928), figure 77, an exceptionally interesting application of the Cubist style to wrought iron. The extraordinary round hat with cockade, the eyes which are tabs of iron bent down from the inner brim of the hat, the perceptively delineated profile, and the aura of strength, capability and bravado are magnificently projected in iron.

Since the virtual disappearance of the horse as a prime mover in this country, the blacksmith, too, has become almost extinct. His difficult craft is now used mostly to produce ornamental work.

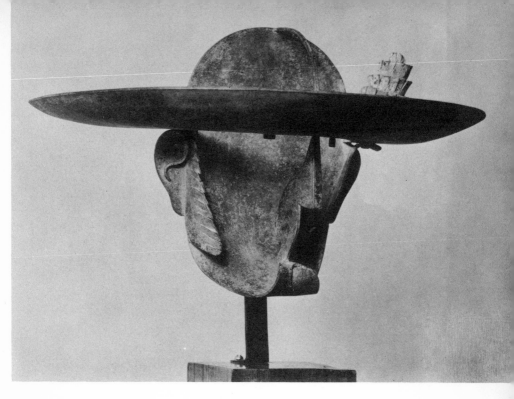

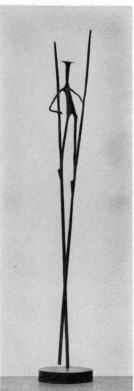

Above: Fig. 77. "Picador." Wrought iron. Pablo Gargallo. (Museum of Modern Art) *Left:* Fig. 78. "Man on Stilts." Forged iron. Paul Aschenbach. (Sculpture Center)

Paul Aschenbach, having worked for several years as an apprentice to a blacksmith who turned out Early American reproductions in wrought iron, has since set up a forge of his own in Vermont, adapting his arduously acquired knowledge to sculpture. He began by manufacturing candlesticks, trivets and other readily salable small objects, and did odd jobs of chain repairing and sharpening stone drills for his neighbors in order to keep his forge going while he perfected his highly individual technique of sculpturing in wrought iron.

In common with metal sculptors who use the welding torch to work directly on the metal, Aschenbach finds the ruggedness and resistance of his material a stimulating challenge. Heating and hammering, reheating and hammering again on long thin bars of iron produces such characteristic pieces as "Man on Stilts" (figure 78). Working swiftly and improvising freely, Aschenbach uses this hard, ancient craft to produce such a droll, sculptural commentary on the contemporary scene as "Speakers' Table" (figure 79), a newsreel vignette in wrought iron.

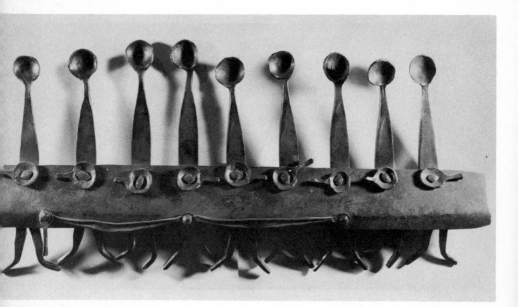

Fig. 79. "Speakers' Table." Forged iron. Paul Aschenbach. (Sculpture Center)

5 CONSTRUCTIONS, MOBILES, STABILES
AND KINETIC SCULPTURE

BECAUSE IT HAS THE LIGHT-HEARTED SPIRIT COMMON TO
all forms of metal sculpture here, Paul Klee's drawing,
"Balance—A Capriccio" (1923), figure 80, is used to
preface this chapter. It is something of a side show
seen in a dream. It is a drawing of the barker's claims
rather than of the actual performance. Klee's delight
in this preposterous mixture is a capricious and fanci-
ful bit of wishful thinking of the type indulged in by
many of us who make mobiles, stabiles, constructions
and kinetic sculpture. In this drawing, done more
than 30 years ago—long before the first mobile bright-
ened our lives—Klee displays the same feeling for a
playful and precarious attempt to defy the laws of
gravity.

Compare Klee's drawing with Rickey's "Cocktail
Party" (figure 81). This piece might be described
(to paraphrase Ruskin) as a little sermon in metal on
cocktail parties. When set in motion, the "guests"
have characteristic movements which are wonder-
fully reminiscent of a whole roomful of people,
glasses in hand, chattering and gesturing, frivolously
earnest or earnestly frivolous as one can only be at a
cocktail party.

Other sculptures by George Rickey appear in their

103

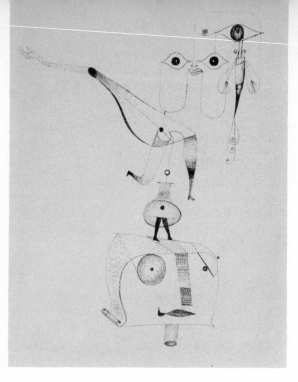

Above: Fig. 80. "Balance—A Capriccio" (1923). Paul Klee. (Museum of Modern Art) *Below:* Fig. 81. "Cocktail Party." Kinetic sculpture. Steel, brass, and polychrome. George Rickey. (Kraushaar Galleries)

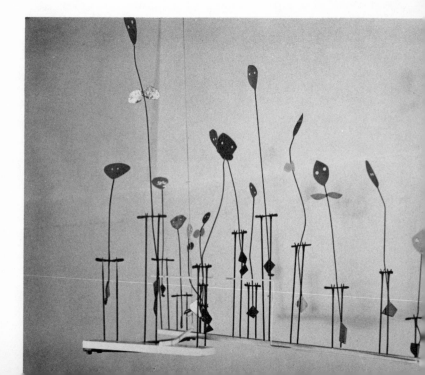

proper place, later in the present chapter, under kinetic sculpture. This form of metal sculpture is a further development of the principles used in constructions, mobiles and stabiles which we should, perhaps, first define.

CONSTRUCTIONS

The line that can be drawn between constructions and metal sculpture is often a very thin one. It might be easier to define constructions, stabiles, mobiles and kinetic sculpture by what they are *not*. They are not sculpture in the classic sense. In other words, the emphasis is never on mass, weight, density or solidity. The accent is on the graphic quality of lines projected into space.

Compare "Full Moon" (figure 82) by Richard Lippold with Lassaw's "Kwannon" (figure 109) and you will have the essential difference between two highly abstract compositions—both linear, both incorporating light and space, but each done from an entirely different point of view. Lassaw is thinking in terms of sculpture. In spite of the fact that there is more space than metal in the composition, it has an organic, sculptural quality. It is as if a once-solid mass had been drawn out and looped back and forth in space ("bronze skywriting"). These attenuated lines, however are modulated, modeled, and as sculptural in feeling as the voluptuous surfaces of a Rodin. In the Lippold "Full Moon" his material—silver wire—is used to create swift, straight lines of light which lead the eye on a geometric exploration. There is no weight, no solidity, no organic modulation.

"Full Moon" is a superb example of a construction. Composed entirely of nickel-chromium wire, stainless-steel wire, and brass rods, it is ten feet high and of an incredible, shimmering delicacy, which beautifully recreates the chaste, silvery radiance of the full moon.

Broadly speaking, wire and rods are the basic materials of constructions. Lippold's "Full Moon" (figure 82) and "Young Venus" (figure 76), the author's "Fish" (figure 83), Stankiewicz' "Abstraction" (steel nails), figure 84, and Gordin's "Rectangular #3" (figure 85) are all constructions which bear out this distinction. The characteristic graphic quality remains even in a robustly three-dimensional structure such as the "Fish" or "Rectangular #3" which is meticulous as a drawing from an architect's drafting board. The "Fish" is composed entirely of soft aluminum wire shaped into an oval by winding and knotting the wire at intervals so that the construction will hold its shape. The wire winds back and forth inside the body of the fish, making a pattern of shallow arcs moving in all directions, suggesting scales and giving a buoyant, floating quality to the construction. An oval, polished beach pebble serves as an eye and rounds out the marine motif. The use of a single material,

Fig. 82. "Variation No. 7: Full Moon."
Construction. Nickel-chromium wire,
stainless steel wire, and brass rods. Rich-
ard Lippold. (Museum of Modern Art)

Fig. 83. "Fish." Construction. Aluminum wire,
stone. John Lynch. (Photo: Herbert Skoble)

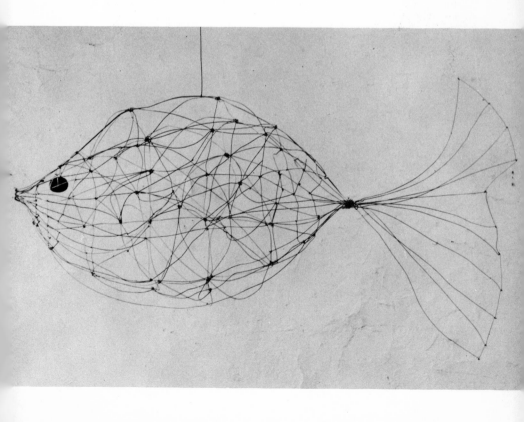

Above: Fig. 84. "Abstraction." Construction. Steel nails. Richard Stankiewicz. (Hansa Gallery) *Below:* Fig. 85. "Rectangular #3." Construction. Black and white painted steel. Sidney Gordin. (Grace Borgenicht Gallery)

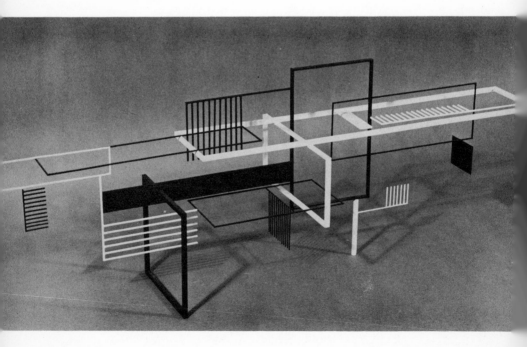

of a series of closely related elements, structural emphasis, repetition of geometric forms, or multiple duplicate elements, are the distinguishing features of all constructions.

Mobiles, stabiles and kinetic sculpture are essentially a three-dimensional arrangement of 2-dimensional materials—wire and sheet metals. They are another form of drawing in space. They are generally more whimsical and meant to amuse. Their shapes are a series of closely related silhouettes floating through space with the mechanical aid of wire arms, which are a subordinate part of the composition.

MOBILES

Mobiles (and stabiles) are a form of metal sculpture developed and carried to *the status of a fine art* by Alexander Calder, who, incidentally, won first prize for sculpture with a mobile at a recent Venice *biennale.* His first true mobiles were made in the early 1930s and were the culmination of a line of experiment which had started with a whole troupe of delightful, animated figures for a miniature circus, progressing through a series of formal geometric constructions called volumes, vectors and densities to groups of animated abstract shapes run by motors which were the mechanized ancestors of mobiles.

The wayward, irresponsible character of a mobile's movement is one of its chief charms. Calder's mobiles always have premeditated tricks which take us by surprise—a sudden flick of a piece at the tail end, the deep downward swoop of a heavily weighted element, an eccentric orbit. The whole range of bobbing, swaying, fluttering, nodding, tipping, sliding movements have an almost hypnotic effect. Mobiles need not, of course, be made entirely of metal. In his "Fish" (figure 87) Calder has utilized what is usually a most useless material—broken glass, arranged within a wire frame as multicolored scales. "Oracles" (figure 88) is composed of aluminum wire, a bamboo stick, beach pebbles, cardboard and nylon thread. Small V-shaped notches were cut in the bamboo with a sharp knife. The vertical wire forms a loop around the horizontal stick. These loops are set in the notches where they are free to rock back and forth. Pebbles are tied to the lower end of each wire form and the whole construction is hung on a nylon thread and balanced by one large pebble. The two rectangles of red and pink cardboard suspended on threads within the innermost and largest circles are in the nature of formal pronouncements. As the mobile revolves, the bamboo stake rocks up and down and the "Oracles" nod sagely to each other.

The same method of construction is used in "Flotilla" (figure 86), where the details of construction can be seen more clearly. The upright wires suggest masts stripped of their sails, while the black forms below are cut in various hull shapes. A large iron washer is

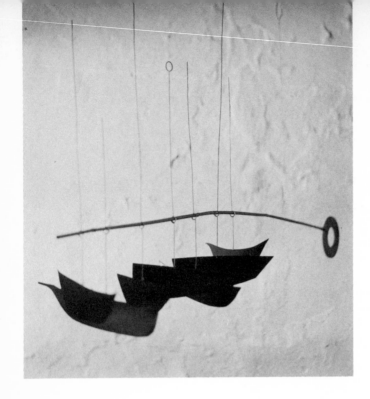

Above: Fig. 86. "Flotilla." Mobile-construction. Aluminum and galvanized iron wire, painted metal, brass, bamboo arm, and iron washer. John Lynch. (Photo: Herbert Skoble) *Below:* Fig. 87. "Fish." Mobile. Aluminum wire with glass. Alexander Calder.

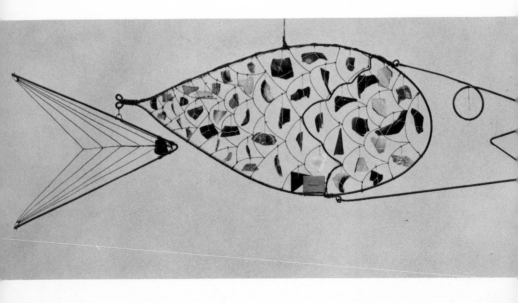

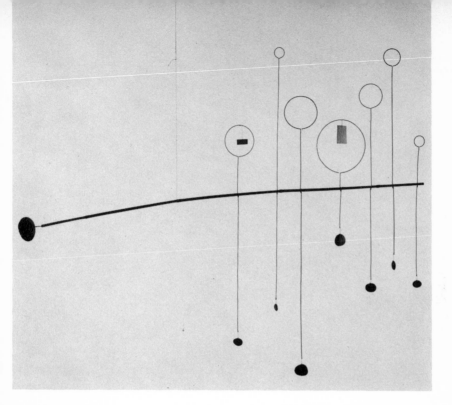

Fig. 88. "Oracles." Mobile. Aluminum wire with beach pebbles, bamboo, cardboard, and thread. John Lynch. (Photo: Herbert Skoble)

the balancing element. As the mobile revolves, the undulating, swaying motion of a group of small vessels at anchor is quite realistically created.

Calder's "Rat" (figure 89) is the only rat one could possibly enjoy. Something of the sinister rodent lingers in the long sharp tail, but the ears and whiskers have been playfully exaggerated. The black horizontal body shape is free to revolve in any direction atop the tripod legs.

STABILES

"Four Planes in Space" (Calder, 1955, figure 90) and the bolted tripod base of the Calder mobile (figure 91) both express very simply the basic qualities of a stabile. A stabile is a combination of rods and sheet metal, or a group of sheets cut in various ways and joined to form a three-dimensional structure with an airy, floating look. Stabiles are halfway between metal sculpture and mobiles.

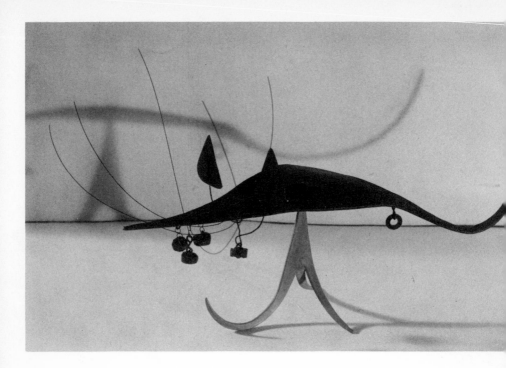

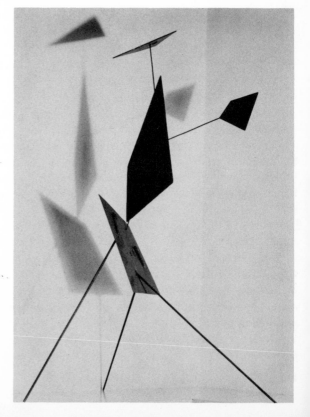

Above: Fig. 89. "Rat." Mobile with stabile base. Wire and painted metal. Alexander Calder. *Right:* Fig. 90. "Four Planes in Space." Stabile. Painted steel. Alexander Calder. (Perls Galleries)

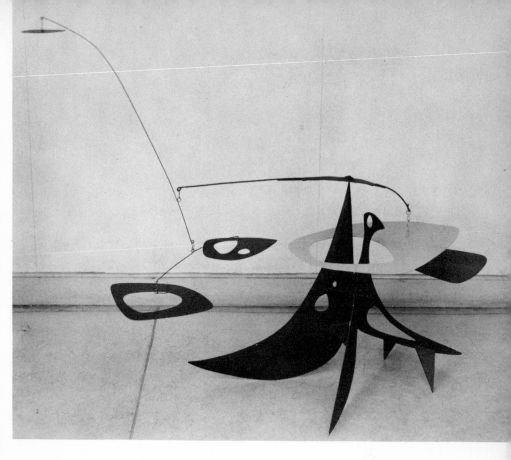

Fig. 91. "Mobile" (with stabile base). Wire and painted metal. Alexander Calder. (Perls Galleries)

Of the three fountains illustrated in this book, the first two (included in this chapter as figures 92 and 93) are closely related to the Calder stabile "Four Planes in Space" of figure 90. The third (Rosenthal, figure 118, Chapter 6) is metal sculpture as defined in the introduction. Cronbach's and Nivola's fountains might be thought of as stabiles put to work. The Cronbach fountain (figure 93) is made of brass tubing bent slightly to form the undulating stems from which water spouts at the top and splashes down on the slightly curved, brightly polished brass leaves. Projecting collars are welded to the tubes at intervals and serve to anchor the leaves to the tubes. This fountain is three feet high and could be used almost anywhere in the garden or even in the living room with a plant arrangement.

Nivola's fountain is a much more permanent structure and is part of an abstract architectural composition. Thirteen brass chutes

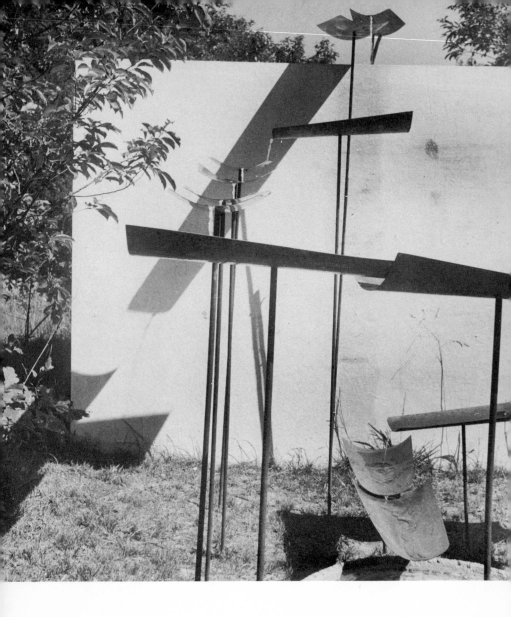

Above: Fig. 92. Fountain. Steel rods and brass chutes. Constantino Nivola. (Courtesy *Craft Horizons) Opposite page:* Fig. 93. Fountain. Brass. Robert Cronbach. (Bertha Schaefer Gallery)

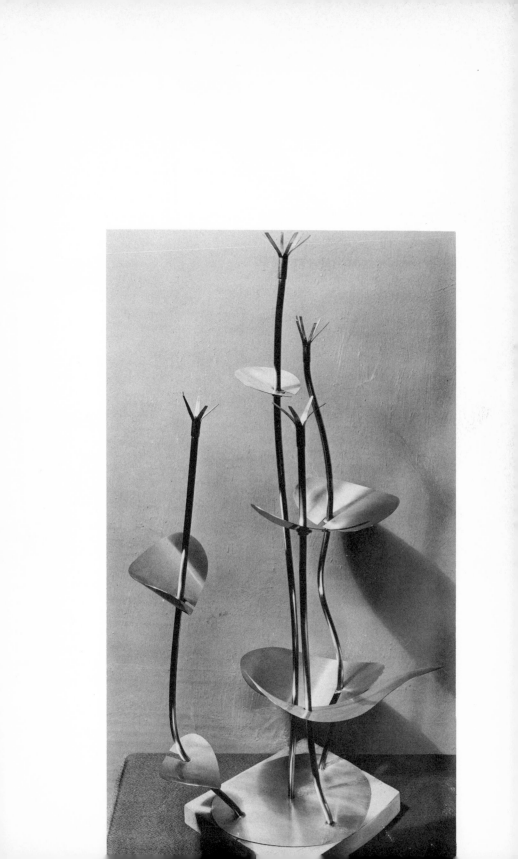

are welded atop heavy steel rods driven into the ground at varying heights. The water cascades down from the topmost chute, placed tantalizingly behind the wall, and into a pool just visible in the lower right-hand corner of the picture. The sharp brass forms, their elegant supports and tinkling water are in dramatic contrast to the dry, white solid rectangle of stucco wall.

KINETIC SCULPTURE

This term has been coined by George Rickey to describe a form of mobile sculpture which has the possibility of movement. It can be set in motion with a very slight push, and because the lighter elements are usually balanced by a very heavy pendulum element, they will continue in motion for an extraordinary length of time, playing through a repetoire of built-in movements. They are not as responsive to vagrant currents of air as are mobiles, and the patterns of movement are more carefully calculated before the construction is built. The shapes are designed to perform a mechanical as well as aesthetic function.

In Rickey's "Triptych" (figure 94) the outer vanes are each cut from a single piece of thin sheet steel. Further cuts are made (decreasing weight) and certain areas are folded at right angles to the vertical, forming horizontal planes which catch up and down drafts, and create more complex visual patterns. The inner vanes are each attached to the opposite ends of the rods, which are pivoted at different heights. The weight and balance point of each arm differs so that they seesaw at various speeds, each slightly out of kilter with the other. This gives a more individual quality to each arm than you would imagine possible. It is as if the construction had an urgent coded message to convey, by a system of semaphore to which the key had been lost. Two interesting techniques have been used, which you might add to your stock of ideas on what can be done with metal. In many ways metal can be treated like paper or cardboard. In "Triptych," Rickey has cut out and folded the sheet-metal vanes as if they were cardboard. He has heightened the visual interest by painting the vanes and by repeating their rectangular shapes in color. Each vane is subdivided into two, four, six, or eight smaller rectangles of color applied in an impressionist manner. These mottled surfaces have a soft, diffuse, weightless texture which visually enlarges the sculpture's scale and adds to its effect of effortless movement.

Rickey's earlier skill with mobiles finds a much greater challenge in the design and execution of such intricate motion systems as "U.N. #3" (figure 95), which demand a high degree of competence and patience combined with good taste and a lively imagination. He does not make a special point of his mechanical ingenuity. The refinement and delicacy of the mechanics blend so

perfectly with the other abstract components of the composition that we are aware only of their aesthetic role and are never made conscious of them as a separate element—"the works," so to speak.

"U.N. #3" is made of brass, aluminum and key steel. Some parts are painted. It is a striking recreation of the gleaming façade of the United Nations building in New York, by now familiar to millions of people. The combination of a static architectural motif (the frame) and mobile strips pivoting within the frame, their swift turnabouts, their reversals, hesitations, unexpected and unpredictable movements, suggest the unceasing activity which goes on within the building. It is a handsome, fascinating construction, enjoyable for its intriguing, inexhaustible mobile surprises.

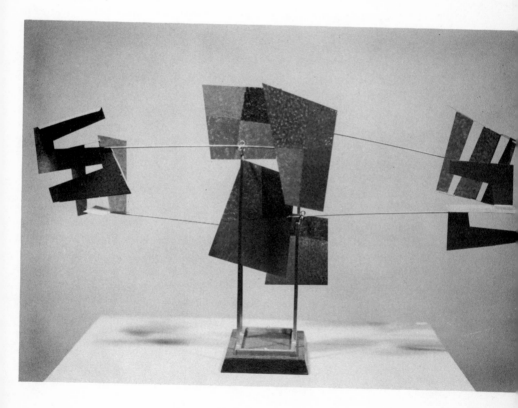

Fig. 94. "Triptych." Kinetic sculpture. Sheet metal. George Rickey. (Kraushaar Galleries)

6 SCULPTURE WITH OXYACETYLENE WELDING

O XYACETYLENE WELDING MAY STILL SOUND RATHER complicated to many readers. Actually, it isn't. Not only is it easy to operate a torch, but perfectly safe provided the usual precautions are taken against fire. Complete operating instructions are given by the manufacturer.

Oxyacetylene welding equipment is used by professional metal sculptors for every type of sculpture from the small abstract, shrewdly observant "Committee" (about 15" high), figure 107, by Richard Stankiewicz, made of scrap cylindrical machine parts, to the spectacular sculptured metal screen 16 feet high by 70 feet wide (figure 123) created by Harry Bertoia for the Fifth Avenue office of the Manufacturers Trust Company in New York. Obviously, this heavy-duty equipment is not needed for joining steel scrap, and Stankiewicz normally uses his equipment for much more serious work on a larger scale, such as "The Secretary" (figure 108). But these examples and all the other illustrations in this chapter are an indication of the great variety of materials and techniques to which oxyacetylene welding may be adapted.

Since it is an industrial tool in use every day on

thousands of welding operations, the oxyacetylene welding torch has been developed to meet the highest job specifications. It was used, for example, on the construction of the U.S.S. *Forrestal,* and is, therefore, certainly more than adequate to the demands of the metal sculptor. This incredible degree of efficiency is one of the reasons why the great variety of metal sculpture shown on the following pages is possible.

Almost any idea for a method of construction or a new use for an old material can be successfully worked out with this equipment. The greatest freedom in handling materials is thus made possible. A good example of what is meant is seen in Barbara Lekberg's "Prophecy" (figure 97), built up entirely from half-inch steel strip—a standard product of the steel mills. The strips have been welded together to form a continuous, flowing sheet (this can be seen most clearly in the scroll), or continued to make the closed, three-dimensional forms of the hands, feet and head. The strips can be bent before, after, or even while being welded to express every nuance the sculptor desires. The finished sculpture is the result of working directly in the metal.

The oxyacetylene torch is not merely a means of joining two pieces of metal; it is also a modeling tool, a cutting tool, and a finishing tool. For the figure of the Prophet, a whole section of the sculpture was reheated after having been welded, to a point where the cloak could be bent into a sweeping curve. Roughly welded forms were reheated at certain points and pushed in or pulled out to form the skillfully modeled three-dimensional legs and hands. Holes cut out with the torch (even without a special cutting attachment) became a highly dramatized rendering of the prophet's hollow eyes and gaunt cheeks. The surfaces of the sculpture may be worked over with the torch, reducing the steel to a puttylike consistency which can be pulled, twisted, roughened or smoothed, modulated and blended with pliers, hammer and other heavy instruments to create very subtle shapes and textures. Smaller elements such as the hands or any other separately made elements may be joined to the larger shapes at any point in the sculpture's development and in any order—or any part of the sculpture may be trimmed or cut off at any time.

Barbara Lekberg, an attractive, petite young woman, works and instructs at the Sculpture Center in New York. She and Juan Nickford have collaborated on several projects. Nickford also teaches at the Sculpture Center and is shown in figure 96 welding a section of a metal mural for the lobby of the New York Trade Center Building. On the floor of the welding studio there are facilities for 8 to 10 people to work simultaneously. I visited the Sculpture Center on a July day. Five people were at work within a few feet of one another in a high-ceilinged room about 20 by 40 feet. There was no excessive heat, mess, nor any noxious fumes. All the

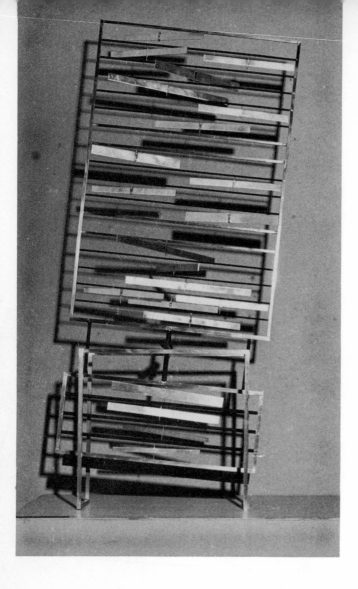

Above: Fig. 95. "U. N. #3." Kinetic sculpture. Brass, aluminum, key steel, and polychrome. George Rickey. (Kraushaar Galleries) *Opposite page:* Fig. 96. Juan Nickford working on a large welded steel mural at New York's Sculpture Center. (Sculpture Center)

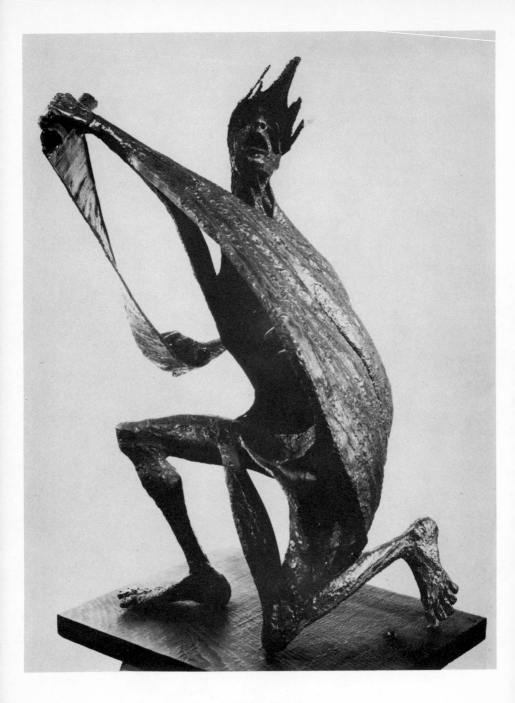

Fig. 97. "Prophecy." Welded steel.
Barbara Lekberg. (Sculpture Center)

sculptors used the welding equipment, materials and tools in common—anvil, mallets and hammers, heavy-duty metal cutters attached to a work table, vises, pliers, clamps and all the other tools. There was no confusion and very little noise—not at all (as you might expect) like a boiler factory. The atmosphere was one of calm, studious preoccupation with the creative task at hand.

Any sculpture, ceramics or painting group or class can get together to purchase equipment. The Sculpture Center, 167 East 69th Street, New York 21, N.Y., provides information on equipment and materials needed to start with. Amateur groups can afford the $200-$300 for basic oxyacetylene equipment to be used and paid for communally.

Colleges such as Sarah Lawrence, a girls' school, have welding classes as part of the sculpture curriculum, and most of the successful metal sculptors teach as well. The amazing versatility of this new tool of sculpture in a woman's hands was demonstrated in a recent show of Women Welders at the Sculpture Center. Barbara Lekberg, Dorothy Robbins and Louisa Kaish, whose sculpture is illustrated in this book—were among them. Saul Swarz, whose "Cat" (figure 98) is an original method of combining ceramic tiles with welded steel, wrote in his introduction to the catalogue for this show:

> Women are not categorized in this exhibition for the purpose of providing shelter for the female sex, but rather demonstrate that our proverbially weaker half is exceptionally strong in this new field of sculptural expression.
>
> To the uninitiated it may appear incongruous for a woman to be welding shapes with molten material and exposing herself to the ravages of spark and flame. But that modern instrument, the welding torch, needs no brute force like the blows at the blacksmith forge. It needs finesse in handling, subtlety of touch and patience, all qualities with which women are largely endowed.
>
> In this exhibition one discerns the kind of discipline which necessarily follows the finding of a new medium, if the artist is to avoid the empty mannerism of medium for medium's sake.
>
> The technique of the welding torch is only the beginning. Welded steel has passed the stage where any piece of twisted wire cleverly tacked together passes for art. Everyone knows the tricks now, and to be called sculpture from now on, it must have genuine merit.
>
> Here we see works indicative of mature artistic background and solid accomplishment. These women have used this new tool with skill and imagination. Their sculptures, woven with flame and rod, exude the freedom and spaciousness of Nature itself in their tenuous lines and contoured masses.

123

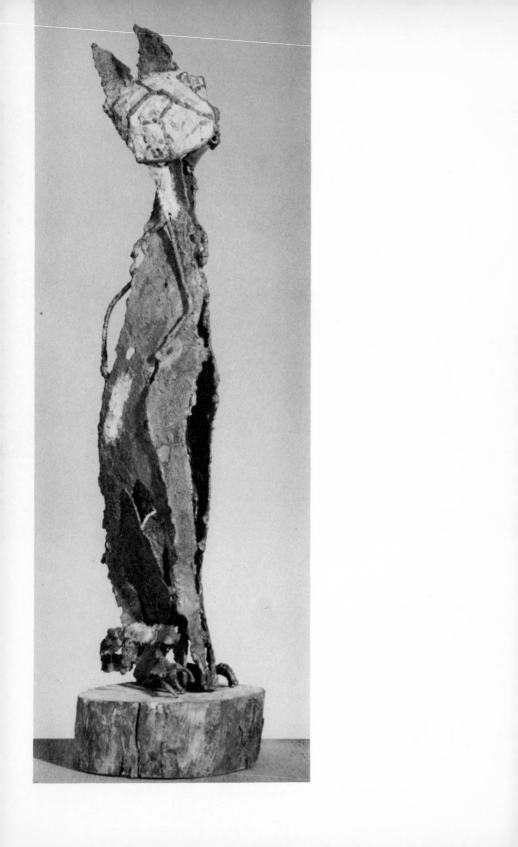

Opposite page: Fig. 98. "Recollection of a Mummified Cat." Steel and mosaic. Sahl Swarz. (Sculpture Center) Above: Fig. 99. "Horse with Flying Arrows." Prehistoric mural at Lascaux, France. (Photo: Caisse Nationale des Monuments Historiques, Archives Photographiques, Paris)

All the sculptors represented in this chapter use essentially the same equipment, yet each sculptor has evolved a highly individual style for which he is internationally famous.

In "Recollection of a Mummified Cat" (1954, steel and mosaic), by Saul Swarz, figure 98, we have a fine example of a technique used by a number of other metal sculptors. Swarz has taken a flat piece of scrap steel and, using the torch as a cutting tool, has made jagged vertical cuts in several places, then by folding the metal has created three-dimensional forms. The metal's worn, rough, gray, scarred surface and the jagged edges combine to recreate this scrawny, tattered animal. Anyone familiar with the vicissitudes in the life of a cat will respond to the forlorn, haunted, rather absurd dignity which cats seem to be able to maintain under the most trying circumstances. Swarz has also used his mosaic technique to perfection in the cat's face. The haphazard whites and grays are a translation of the somewhat clownish face achieved by the cat-in-the-street when left to its own devices.

Tom Hardy is both a rancher and an artist. He finds models for his stylized animals in the livestock of his Oregon ranch and the wild inmates of Western zoos.

He says, "My sculptures usually start with observations of nature, but sometimes they proceed one from another. In watching living things I look for the unique combinations of form that seem characteristic of the animal and which also suggest a particular manipulation of material. A piece may be suggested by the way a horse stretches his neck—that is, one phase of articulation may suggest a whole set of matching shapes, contours, or lines.

"Sometimes I cut patterns of heavy paper, especially if working with sheet metal; then, after the necessary adjustments, transfer the patterns to the metal. Of course the metal doesn't react exactly like the paper after cutting and bending or forging, so the design is constantly modified as the metal has its say. I like to respond to the metal as it tries to be itself, and I always object to shaping it into uncharacteristic form or texture.

"I do not care for highly machined edges and surfaces—consequently I usually leave the rough beaded edges of steel caused by the torch as the oxygen burns its way through; [See detail of "Old Goat," figure 104] and I usually allow the copper to retain the multiple colors that it assumes under intense heat.

"I generally do not use acids on the metals, preferring instead to have them darken or rust evenly with time. I have worked with sheet rod and wire steel, strap and sheet copper, sheet and rod brass, and silver and combinations of these metals, but copper and silver are my favorite because of their warmth and responsiveness."

Oliver Andrews' sculpture, simple in its design and direct in its handling, is exceedingly refined, elegant, aloof. It is not to be fondled. It evokes the imagery of ancient instruments and weapons,

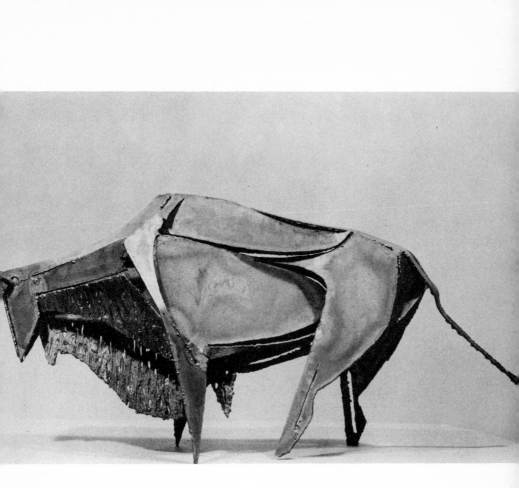

Fig. 100. "Bison."
Welded sheet steel.
Tom Hardy.
(Kraushaar Galleries)

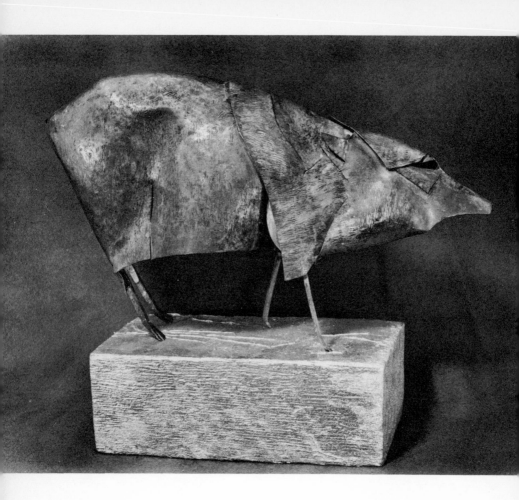

Above: Fig. 101. "Peccary." Welded forged copper. Tom Hardy. (Kraushaar Galleries) *Opposite page:* Fig. 102. "Porcupine." Welded steel wire, spotted with bronze and nickel silver. Tom Hardy. (Kraushaar Galleries)

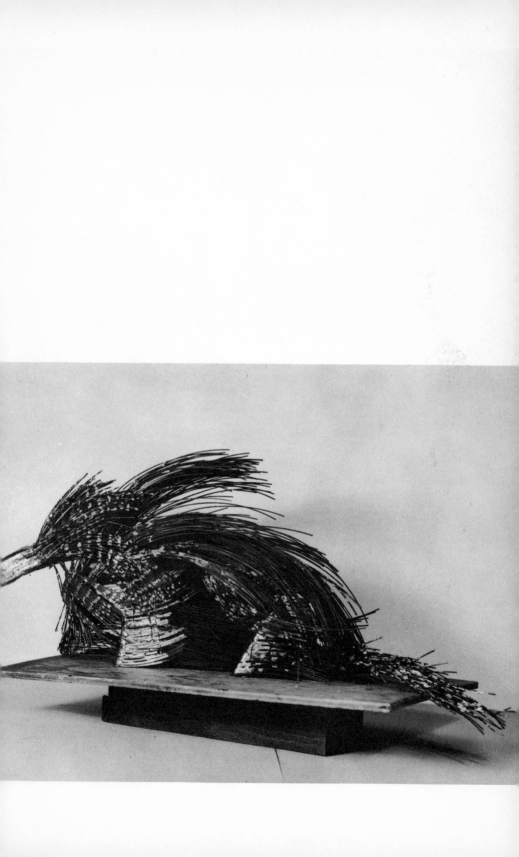

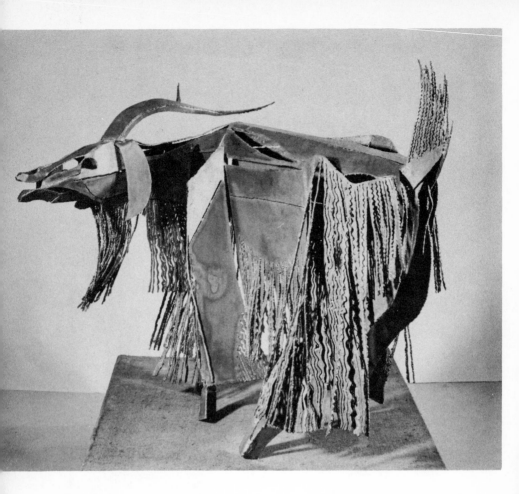

Above: Fig. 103. "Old Goat."
Welded steel, oxyacetylene cutting.
Tom Hardy. (Kraushaar Galleries)
Right: Fig. 104. Detail of figure
103.

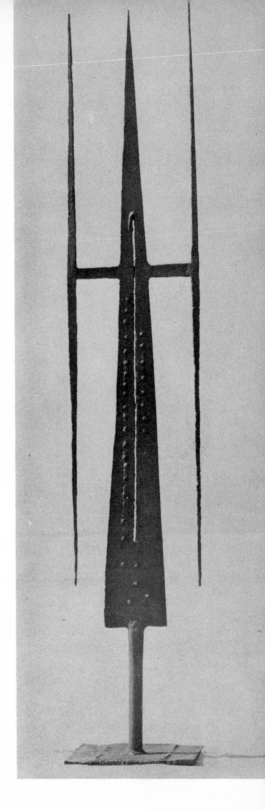

Fig. 105. "The Keeper of the Night." Welded steel, painted black. Oliver Andrews. (Alan Gallery)

as in "The Keeper of the Night" (figure 105), and the timeless mystery of the sky and the world around and under the sea, as in "Stalks" (figure 106). Andrews uses his torch with great discretion, and considers welding a means—an unobtrusive way of joining metal forms—and not as an end in itself.

"The Keeper of the Night" (1954), of welded steel, painted black, is like some primitive ritual object, well able to hold its own against evil spirits. A large tough black sentry, rigid, unsleeping and fearfully armed, it is impersonally malignant and aggressive.

"Stalks" (1954), made of welded bronze, derives its imagery from the shores of the Pacific, where Andrews has spent almost all his life. He has constructed an outrigger canoe in which he travels far out to sea and, quite naturally, has fashioned his own steel harpoons to spear fish. He spends much time diving to great depths, hunting and observing the world under water. "Stalks" is certainly a successful translation of those rubbery, mysterious marine plant forms which all of us have seen (at closer range) washed up on the beach or tangled around rocks. It also strikes me that since it is a vertical construction Andrews did have in mind some plant seen on the ocean floor, growing up toward the light and putting out innumerable feelers in every possible direction. This sentient quality seems more characteristic of marine plants than of their dry-land relatives, which are a trifle more relaxed and even smug about their superior role in evolution.

In "Committee" (figure 107) and "Secretary" (figure 108), Stankiewicz' use of found objects—cast-off parts of typewriters, boilers, refrigerators and much more esoteric machinery—as the raw material for his sculpture always results in a remarkably convincing connivance between this artist and his material.

Another pioneer in contemporary metal sculpture is Ibram Lassaw. Once an idea has become sufficiently well formulated, Lassaw begins his work with the basic material from which the sculpture will be built up. Rough sketches are made in 10-gage wire, which also serves as an armature. These are placed on a sheet of white paper cut to the size planned for the completed work, and suggesting space. When these units have been developed further and joined, the skeleton is lifted onto a low trestle of transite sheet, enabling him to work on the reverse side. Several weeks are spent adding smaller, more complex clusters of lighter-gage wire which serve both to strengthen the work and intensify and refine the basic design.

Lassaw's method of working with wire is very much like freehand drawing. A length of wire is fastened at one point, then heated with the torch at another. The wire is softest where it has been heated and can be bent in any direction by holding it with the pliers at its hottest point and bending with the other hand. The wire is not snipped off until it has served its purpose. By working

Fig. 106.
"Stalks."
Welded bronze.
Oliver Andrews.
(Alan Gallery)

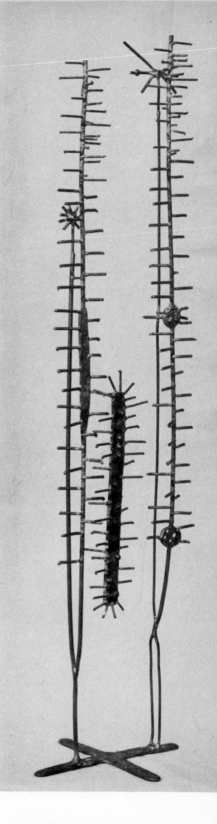

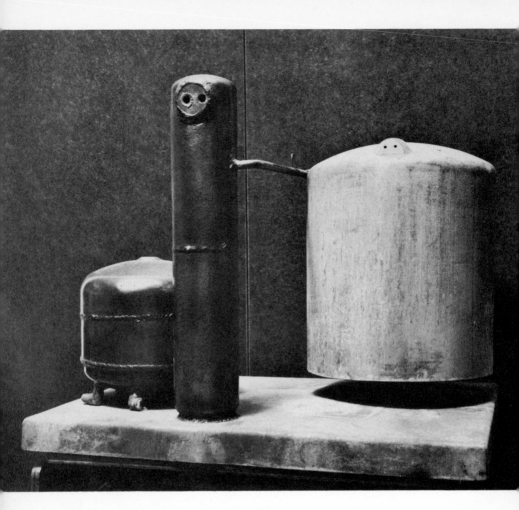

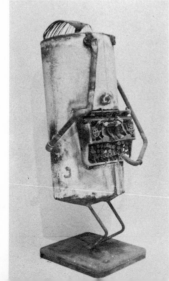

Above: Fig. 107. "Committee." Steel. Richard Stankiewicz. (Hansa Gallery) *Left:* Fig. 108. "Secretary." Scrap metals and typewriter. Richard Stankiewicz. (Hansa Gallery) *Opposite page:* Fig. 109. "Kwannon." Welded bronze with silver. Ibram Lassaw. (Museum of Modern Art)

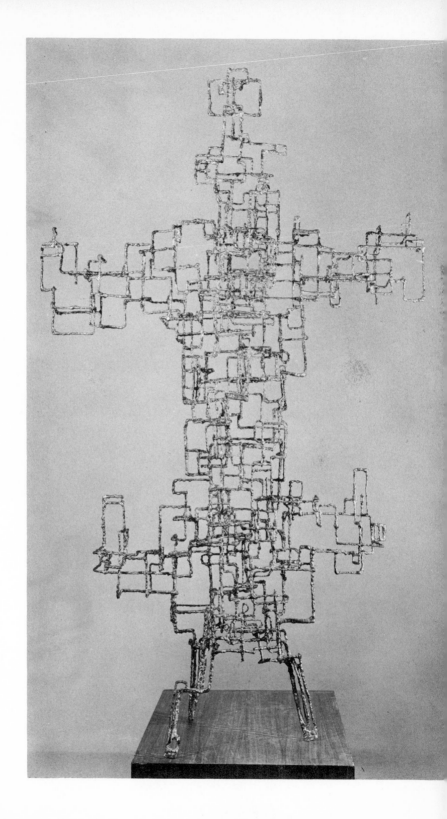

with long wires, Lassaw is free to use any or all of the wire in any way that might suggest itself at any point in the work. He need not lay down his torch to search for a small length of wire. No portion of the sculpture is so premeditated that pieces are cut beforehand and fitted into place. Instead, minor alterations and additions are constantly made while the work is in progress, and any new forms that enter into the spirit of things are swiftly incorporated. The sculpture is then suspended in space, and bronze and silver (which melt at a lower temperature than iron) are welded to the armature in small globs. This also strengthens the entire work.

Other metals that can be melted over an iron armature are stainless steel, brass, copper, chromium bronze and nickel silver. Various chemicals such as zinc chloride, copper chloride, potassium nitrate, potassium sulfide, nitric acid and lead acetate are applied to parts of the sculpture, producing accents of color—coppery blue-greens, pinks, ruby reds and rusty browns—which combine beautifully with the soft, liquid gleam of bronze and silver.

Lassaw's "Kwannon" (1952), the Chinese goddess of mercy, figure 109, is a superbly representative work. The precious quality of the metals (welded bronze and silver), the use of space and light, create a nice balance between reality and abstraction proper to the goddess. She has traditionally been carved in jade or ivory—both materials at once lovely, calm, and remote in feeling. Lassaw treated the subject abstractly; he has used the space within the sculpture to suggest in a sophisticated manner the airy, unimpassioned, yet merciful role assigned to this deity.

Lipton's "Sanctuary" (figure 110) is like an unfolding metallic rose. Space is enfolded, almost fondled by the gently curving surfaces of sheet steel, and is contained within the sculpture as an element of composition. Light is reflected and diffracted from surfaces stippled in an impressionist manner with small dots of nickel silver. Unlike some other sculptors who revel in the jagged hardness of raw metal, Lipton uses these folded leaves of metal to create softly glowing organic forms.

Roszak's thorny "Spectre of Kitty Hawk" (figure 112), is the antithesis of de Rivera's controlled, lucid "Sculpture Construction 2" (figure 113). It is a violent outburst of energy expanding in every direction at once. Even its description—welded and hammered steel, brazed with bronze and brass—has a rather Wagnerian ring. Roszak is a sculptor whose absolute mastery of the techniques of welding and knowledge of metals frees him to work authoritatively, infusing an inert mass of metal with dynamic, pulsating life, so that the sculpture seems to be growing and absorbing space and light into itself in obedience to some inner dictate.

If I had not seen several sculptures in progress at de Rivera's studio, I could hardly have believed that "Sculpture Construction 2" in all its liquid, silvery sumptuousness could have been devel-

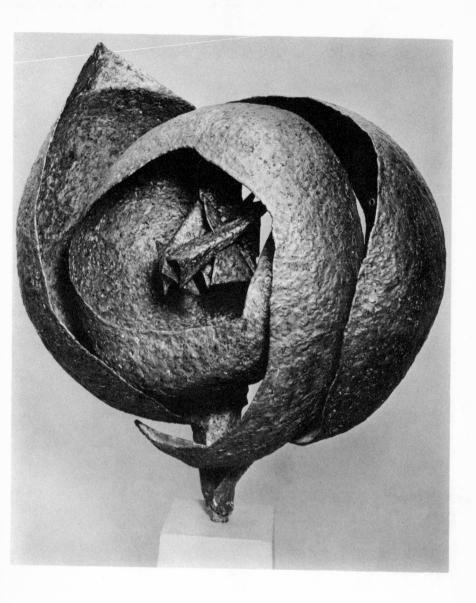

Fig. 110.
"Sanctuary."
Nickel silver over steel.
Seymour Lipton.
(Museum of Modern Art)

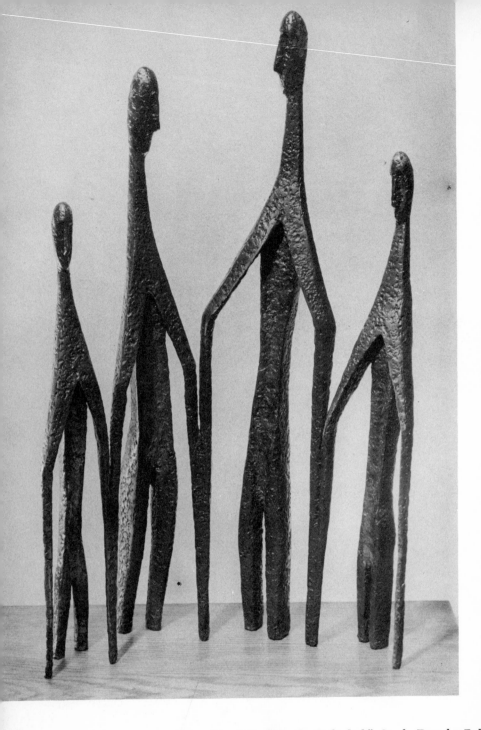

Above: Fig. 111. "Family Cathedral." Steel. Dorothy Robbins. (Sculpture Center) *Opposite page:* Fig. 112. "Spectre of Kitty Hawk." Welded and hammered steel brazed with bronze and brass. Theodore J. Roszak. (Museum of Modern Art)

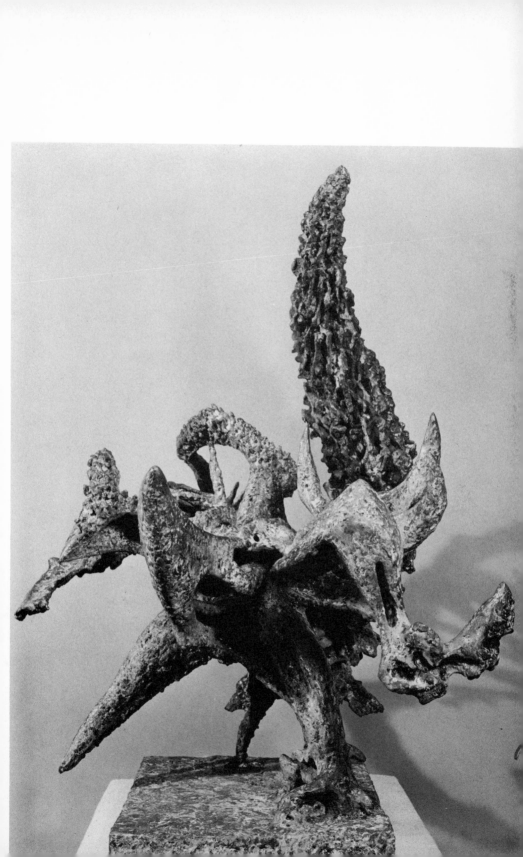

Above: Fig. 113. "Sculpture Construction #2." Twelve-gage chrome, nickel steel sheet, welded. José de Rivera. (Mrs. Albert A. List, Collection) *Opposite page:* Fig. 114. "Men Fishing from a Pier." Iron wire. Leslie T. Thornton. (Museum of Modern Art)

oped from very undistinguished, dusty metal sheets, stacked haphazardly in one corner of the room. The one quality more than any other which distinguishes de Rivera's work is its sheer physical beauty. It is literally breathtaking. Light speeds along the coolly sensuous, gleaming surfaces so effortlessly that the sculpture seems created for just this purpose. Employing the tools, techniques and materials used by his contemporaries, de Rivera brings his lustrous creations to such a high degree of polish and elegance that we are free to enjoy the finished work without visual reference to any of its stages of development. It is a gift from the artist to the public. His sophisticated conception is not unveiled until every trace of the labor by which it was brought to completion has been banished. De Rivera started work on "Sculpture Construction 2" by cutting a strip of the metal from a sheet. Then by a process of heating and hammering very much in the now romantic style of a blacksmith (except that an oxyacetylene torch is used instead of a glowing bed of coals) the metal is roughly shaped and drawn towards its sinuous future. This is done on a large block of tin or lead, scarred and misshapen from years of use. The tin or lead block has just the right consistency to allow the harder metals to be pounded without bouncing about and to absorb and thus soften the overlapping edges of the hammer blows. When one lengthwise half of the intended form has been shaped and smoothed to a certain point, it is set aside until the other half has been developed to a comparable state. The two halves are then joined along their entire length by welding. The slight roughness produced by making these seams is ground completely smooth. This can be done on a grindstone or emery wheel. The metal is still dingy and smoky as a result of its rough treatment. But it is now ready for its final grooming. This is accomplished in stages through meticulous polishing by dozens of successively finer grades of abrasive, until all the beauty inherent in the metal is brought to life.

Sculpture, of all the arts, has always been the most closely identified with public life, and as architecture evolves steadily away from ponderous, massive structures designed to impress, so does sculpture. These two forms of creativity have always been closely linked to one another. Sculpture, whether in the form of columns, pediments or other formal sculptural embellishments, or as heroic human and animal figures, are complementary to architecture. Buildings without one sculptural device or another would be uncomfortable, forbidding. To enter such a building would be too abrupt a change from the natural disorder of the everyday world. Sculpture provides the necessary intermediate link through which we can relate ourselves, in scale, to a large building, or one of public character—that is, a building which is not our home, which we do not take for granted.

As architects progressively dematerialize the physical appearance

Fig. 115.
"Wind and Waves."
Welded bronze.
Juan Nickford.
(Sculpture Center)

Fig. 116. Mural at Randall House, New York.
Shaded bronze. Juan Nickford.

of buildings and substitute abstractions in steel and glass for sculptured stone, sculptors—in response to the same picture of the real nature of the world which scientists are steadily bringing into sharper focus—are creating work in which space, light and form are of equal value. The complex interplay of these three factors is of greater interest than specific, literary, sentimental imitation of natural forms. All the commissioned sculptures shown on the following pages bear out this point in various ways.

Light, space and motion are the themes of Nickford's sculpture of welded bronze, "Wind and Waves" (figure 115), created for the Malibu Beach Club, Long Island. This formal, symbolic interpretation precedes the actual experience which takes place on the other side of the building and thus relates and dramatizes the function of the buildings to the public, before they have entered.

Victor Ries' gates for the sanctuary of a synagogue (figure 117) are transparent enough so that the Torah within can be seen, while at the same time they gracefully interpose a decorative visual allusion to the Biblical "fruits of the earth." By using space and light as elements of composition, they enhance and enrich the symbology of the ark without detracting from its central importance.

Richard Lippold's spectacular "Variations Within a Sphere No. 10: The Sun" (figure 119) is a sculptural construction made of gold wire, 22 feet long by 11 feet high by 5½ feet deep. Stainless-steel guy wires attached to walls, floor and ceiling hold the construction in tension. It is a symmetrical object with a rotating spherical core, 40 inches in diameter, surrounded by a number of radiating planes in the form of arcs, the whole suggesting the nucleus of the sun surrounded by its corona and prominences.

Conceived specifically for the Metropolitan Museum in 1950, "The Sun" was commissioned by the Museum in 1953. Robert Beverly Hale, associate curator of American Painting and Sculpture, says of this work, "Though it is extremely subtle, it is not esoteric. Its radiant geometry can be enjoyed and appreciated by everyone." The first of a series of spherical variations appeared among Lippold's works in 1946. The seventh of the series became the magnificent "Full Moon" (figure 82) now in the collection of the Museum of Modern Art; the others are privately owned. "The Sun" is Lippold's most ambitious undertaking to date and took three years in the making. Almost two miles of the delicate gold wire was used in the construction, which contains more than 14,000 hand-welded joints.

"The Sun" has been placed for its first showing in a gallery of the Department of Near Eastern Art at the artist's urging. Lippold states, "I feel that an awareness of any similarities and differences that may exist between East and West is a vital necessity of our time. If this work, assisted by a tranquil and contemplative atmosphere and spacious proportions, helps to illuminate a possible

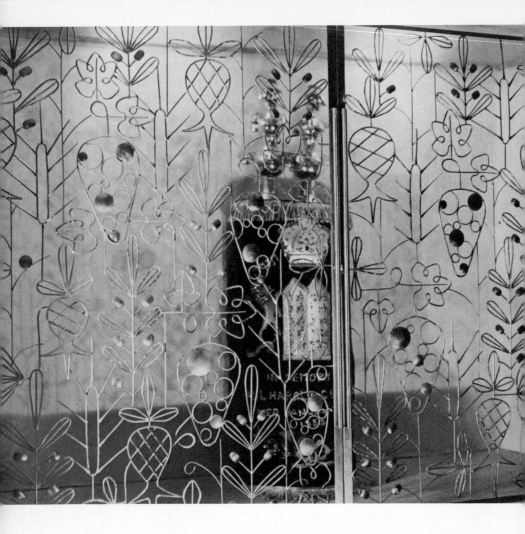

Above: Fig. 117. Sanctuary gates. Welded silver wire. Victor Ries. (Courtesy *Craft Horizons*) *Opposite page:* Fig. 118. Fountains. Welded steel. Bernard Rosenthal. (Courtesy Raymond Loewy Associates)

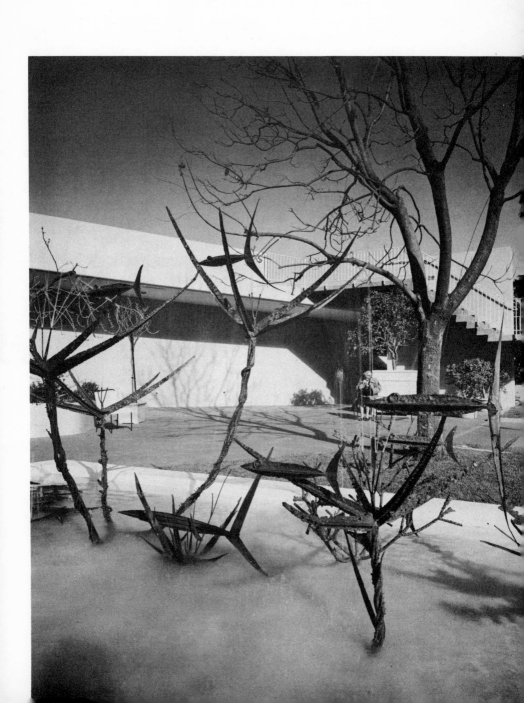

rapport between such seeming opposites, it will have fulfilled its intent and justified its existence beyond a mere object of decoration or private expression."

Highlighting the main banking room on the second floor of the Fifth Avenue office (at Forty-third Street) of the Manufacturers Trust Company in New York is a dramatic six-ton, seventy-foot metal screen by Harry Bertoia (figure 123). Eight hundred metal panels measuring 7½ inches by 30 inches are the basic unit of design and are arranged in varying depths throughout the screen. The variation of spacing and the play of light and shadow on the textured panels, which can be clearly seen in figure 123, lend unique interest to the work.

This huge screen is illuminated by a series of 150-watt spot and flood lamps mounted on adjustable swivel brackets and concealed behind the aluminum plates in the luminous ceiling. The screen was assembled from seven major sections, each 10 feet by 16 feet by 2 feet, with panels arranged in six vertical tiers and held in place by steel connecting bars. The texture and tones of the panels were achieved by fusing brass, copper, and nickel to the smooth surface of ⅛-inch enameling steel, as Bertoia is shown doing in figures 120 and 121. This brazing process was painstakingly accom-

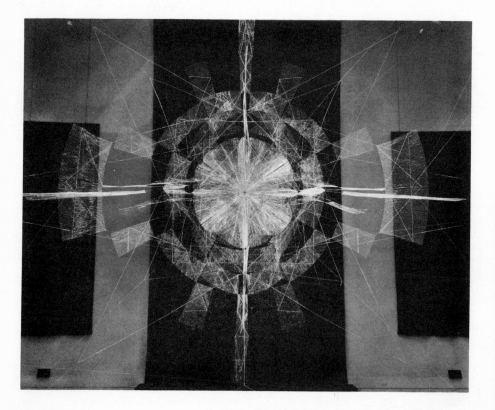

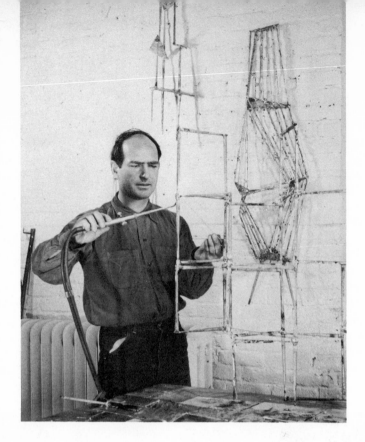

Opposite page: Fig. 119. "Variation Within a Sphere, No. 10: The Sun." Gold wire. Richard Lippold. (Metropolitan Museum of Art) *Above:* Fig. 120. Harry Bertoia coating raw metal with nickel by means of an acetylene torch.

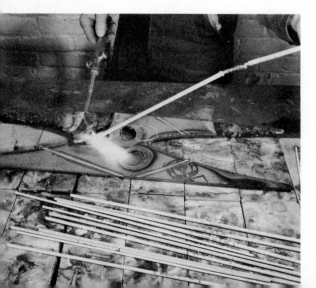

Fig. 121. Brazing with alloys of nickel, brass, and copper fuses these metals to steel, adding interesting texture and color. Welding rods are shown in foreground.

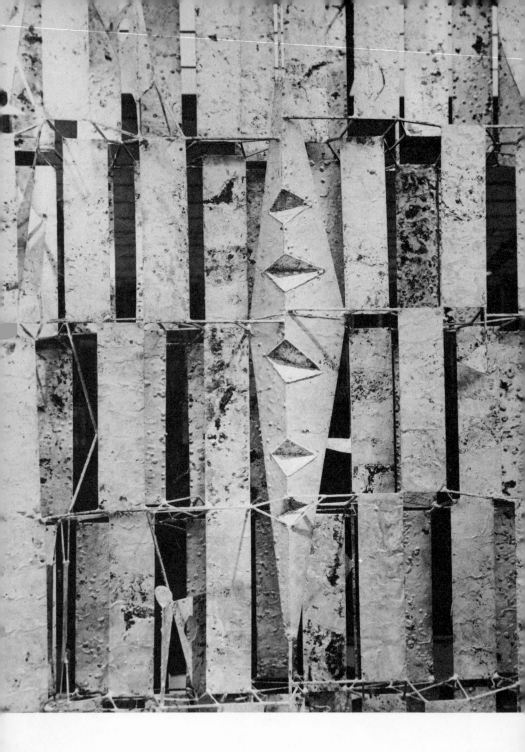

Opposite page: Fig. 122. Detail of metal screen at the Fifth Avenue office of the Manufacturers Trust Company. Harry Bertoia. *Below:* Fig. 123. Complete view of Bertoia's screen shown in detail in figure 122. (Photo: Ezra Stoller)

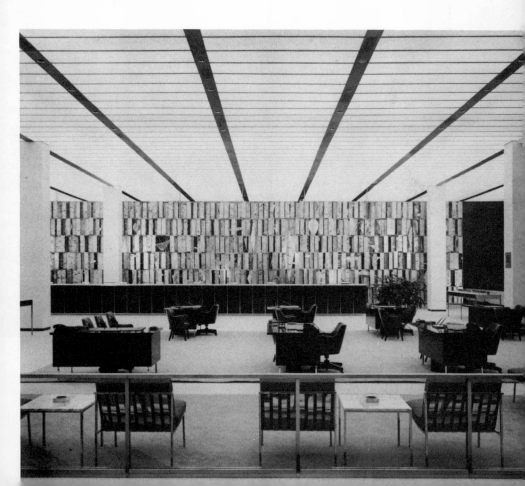

plished with an acetylene torch and welding rods of various compositions. Final step was to paint the screen with two protective coats of lacquer.

Because of the size of this screen, his largest work to date, Bertoia, who normally works in a barn on his farm near Barto, Pennsylvania, had to shift operations to a garage in a nearby town. He took eight months to complete this work.

José de Rivera's sculpture, figure 124, done for the Hilton Hotel, Dallas, Texas, is an extraordinarily brilliant response to the new scientific interpretations of the nature of the world, to which we are all learning to orient ourselves. The work is approximately 9 feet high by 13 feet long by 10 feet wide. It is made of 12-gage chrome, nickel-steel sheet, with the exterior highly polished and the interior painted cadmium yellow; it incorporates motion as its fourth dimension, making one complete revolution in six minutes. The circle of nozzles, just below its base, project a downward curving sheet of water which really becomes the base for the sculpture. The glistening sheets of water repeat the reflecting surfaces of the sculpture, its motion and curves, completely destroying the last vestige of solidity by providing a mobile base for a mobile sculpture.

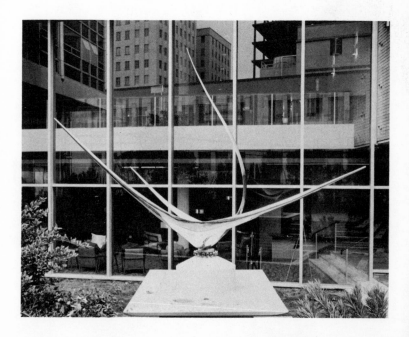

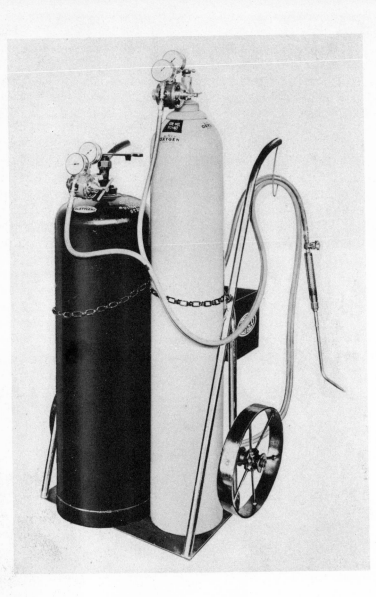

Opposite page: Fig. 124. Sculpture construction made for Statler Hilton Hotel, Dallas, Texas. Chrome, nickel steel sheet, 12 gage. Polished exterior, cadmium yellow interior. José de Rivera. *Above:* Fig. 125. Oxyacetylene welding unit.

This book may be kept